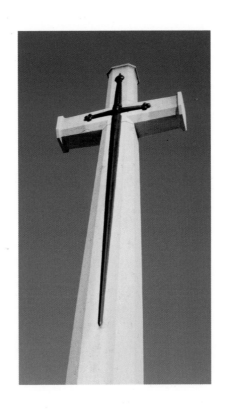

REGIMENTS
OF THE DEAD

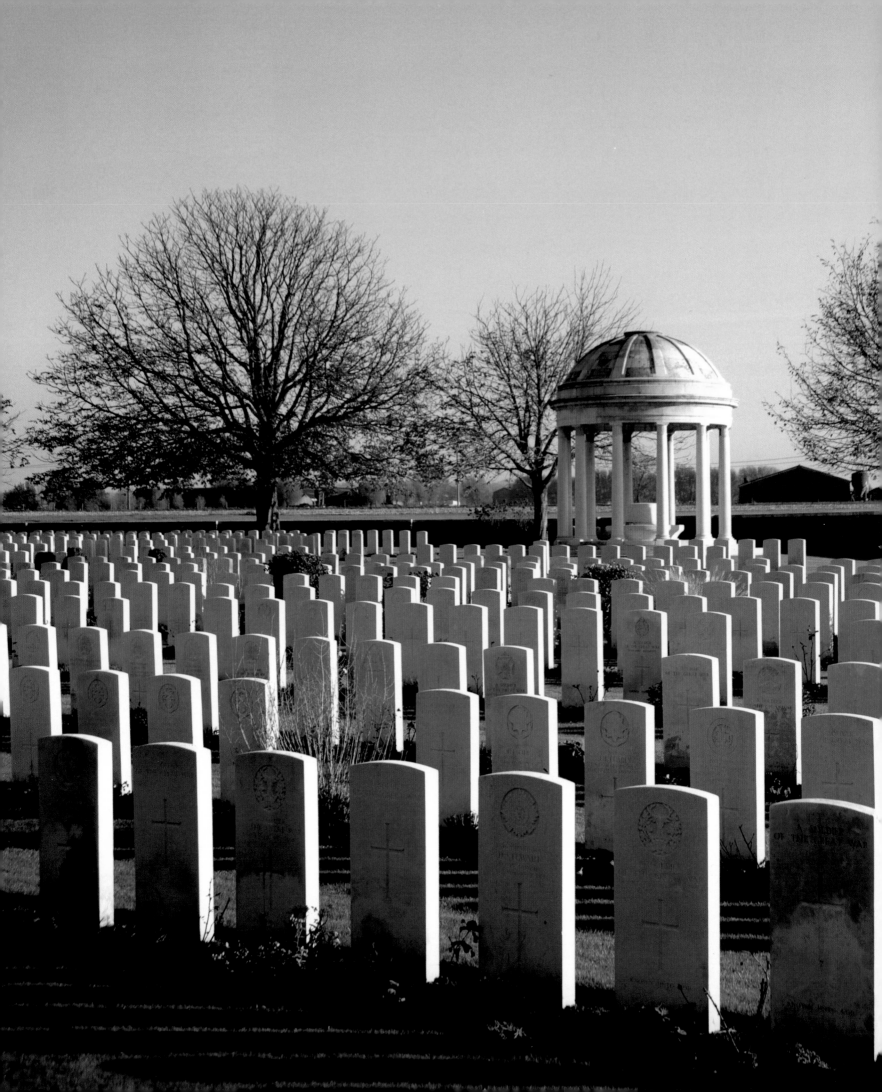

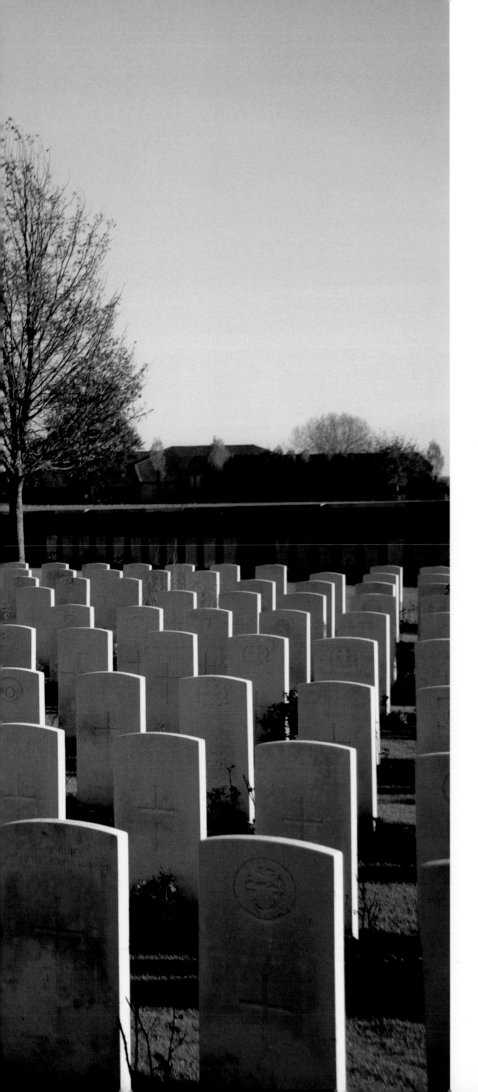

REGIMENTS OF THE DEAD

WAR GRAVES OF FLANDERS

PHOTOGRAPHED BY

PAUL SHENTON

PALIMPSEST

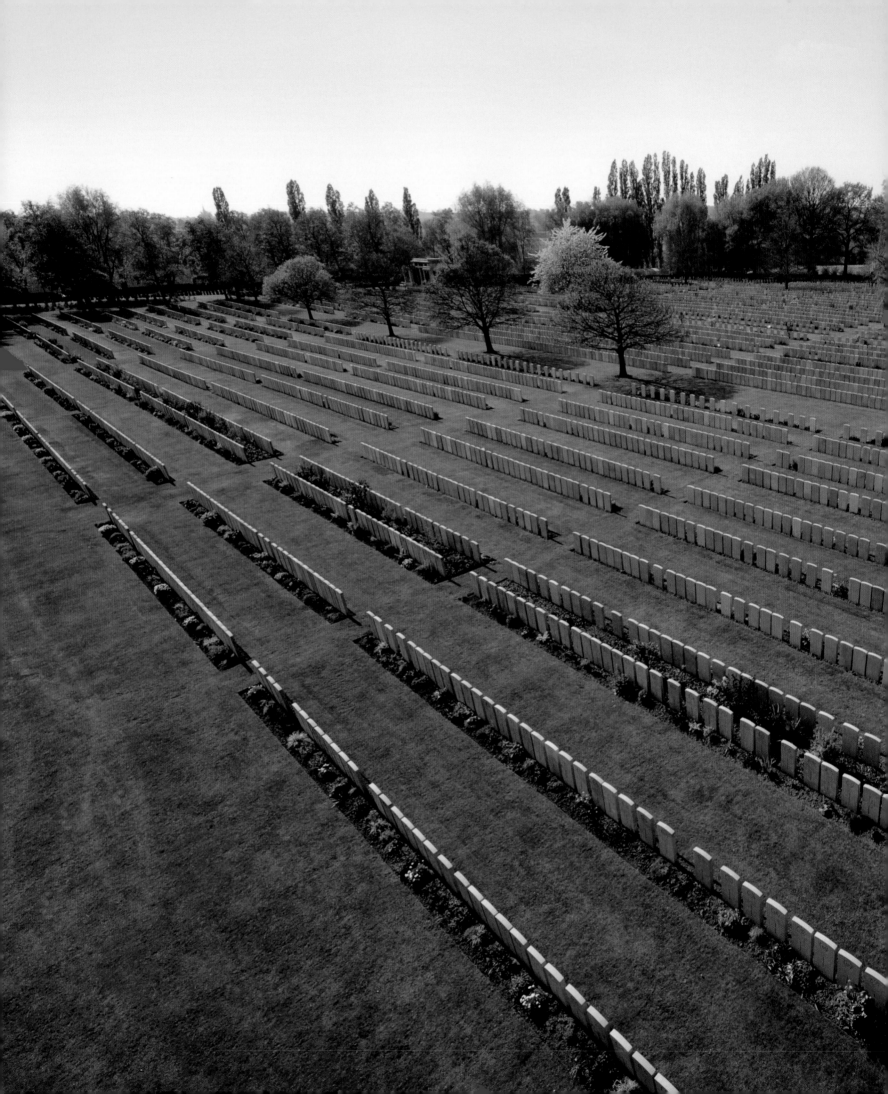

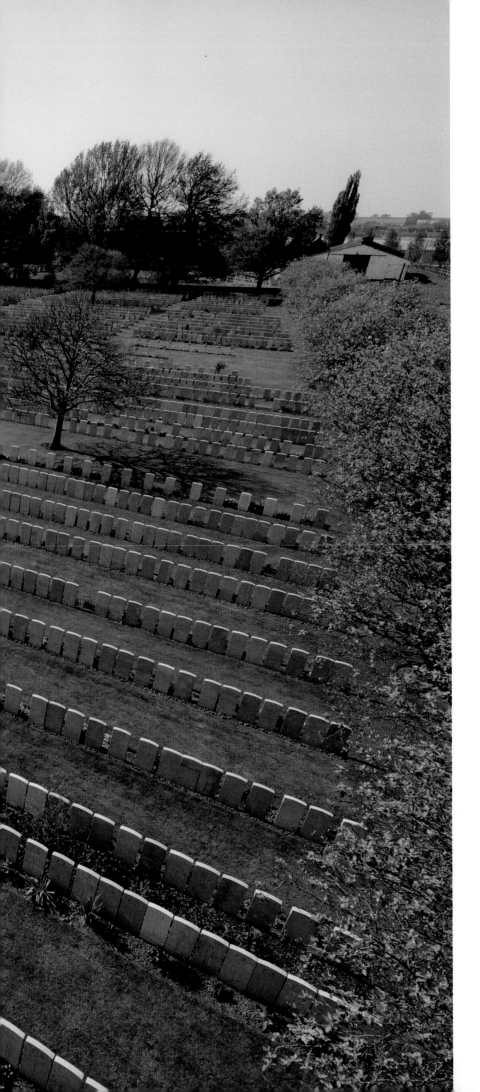

CONTENTS

'We are the Dead. Short days ago
We lived, felt dawn, saw sunset glow,
Loved, and were loved, and now we lie
In Flanders fields.'

FROM *IN FLANDERS FIELDS*
BY LIEUTENANT-COLONEL JOHN MCCRAE MD, 3 MAY 1915

HALF-TITLE PAGE: Cross of Sacrifice – Tyne Cot Cemetery.

TITLE PAGE: Bedford House Cemetery.

CONTENTS PAGE: Lijssenthoek Cemetery.

INTRODUCTION

The year 2014 marked the hundredth anniversary of the beginning of the First World War. Between 1914 and 1918 hundreds of thousands of British and Allied troops from the Empire, and opposing forces from Germany, came to fight in the trenches of Flanders. Many never returned home; they are buried in the numerous cemeteries of the Ypres Salient and beyond. Others are remembered only by name, carved into the wall panels of the Menin Gate and the walls of remembrance in the great military cemeteries.

The cemeteries, perfectly maintained by the Commonwealth War Graves Commission are places of great beauty, dignity and tranquillity, fitting memorials to those who lie interred within.

This book seeks to show in a series of exceptional photographs, from viewpoints that have rarely been seen before, a selection of the best-known cemeteries as well as some of the smaller, out-of-the-way ones. They are the result of many visits to Flanders in different lights and at different times of year. As the photographs speak for themselves, and there are numerous other written publications detailing the cemeteries, the accompanying text has been kept to a minimum.

The story starts with images of Ypres; the medieval Cloth Hall, destroyed during the war and later rebuilt, the Cathedral and the Menin Gate Memorial, constructed on the site of the original city gate, which all troops passed through on their way to the front. The photographic narrative follows the path some of these troops would have taken to their final resting place, providing an evocation of place like no other.

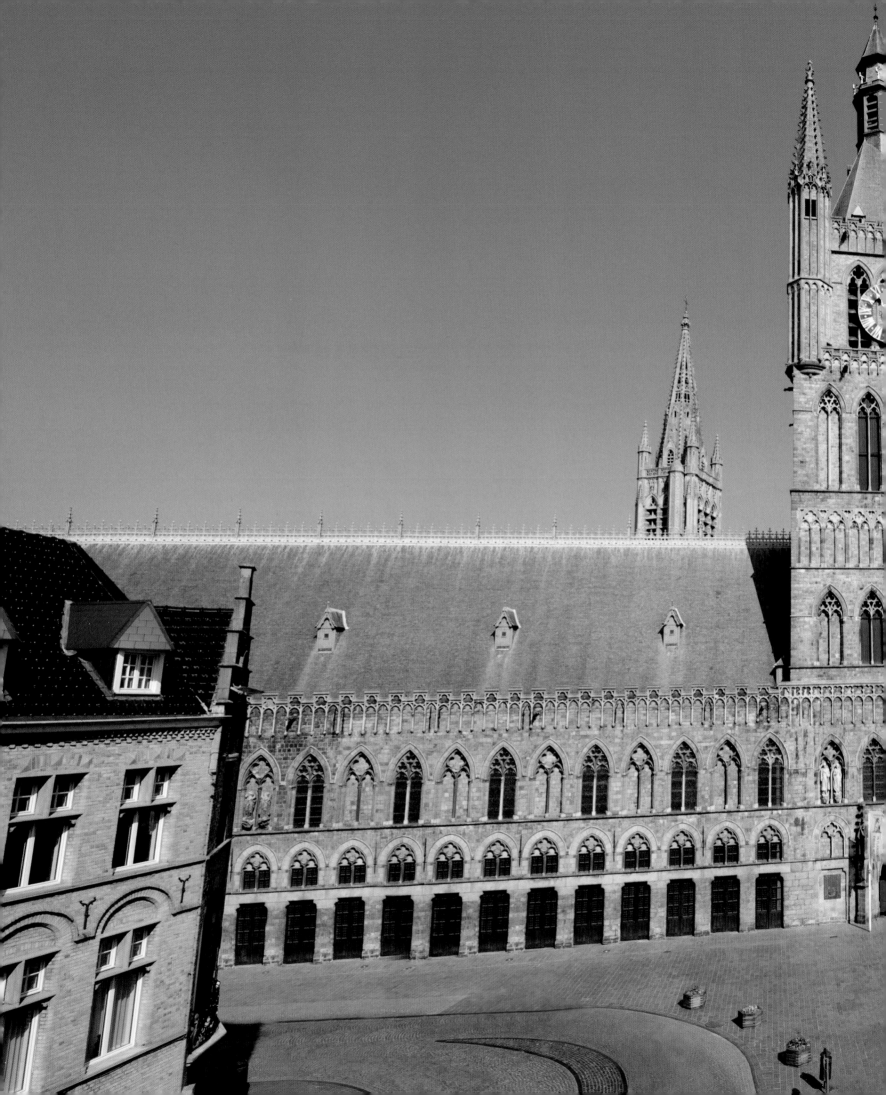

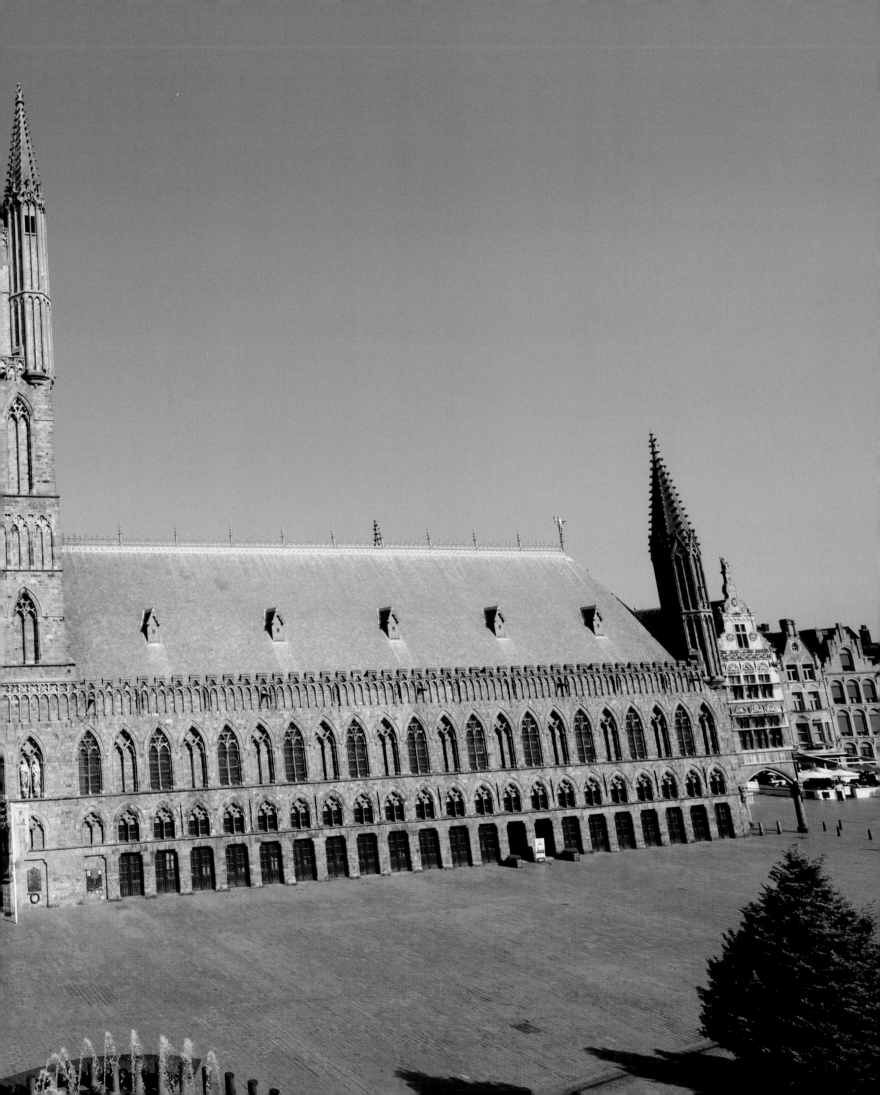

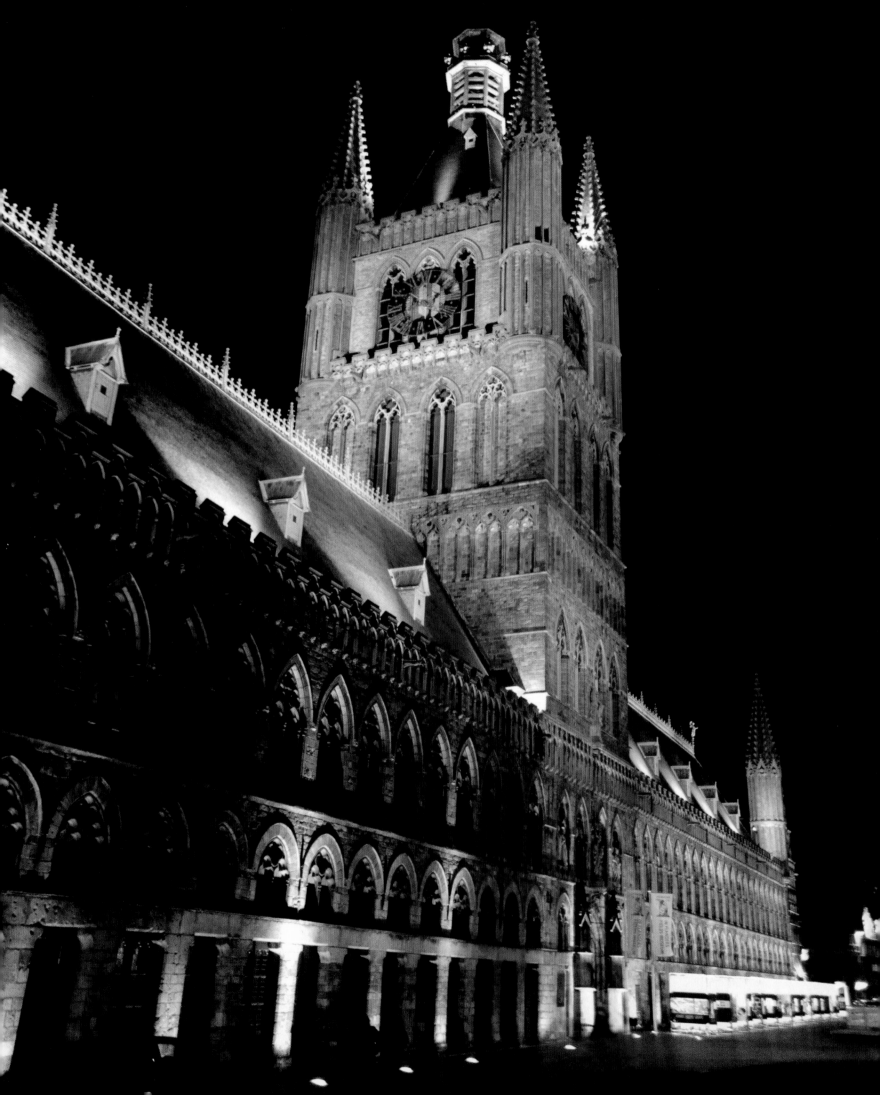

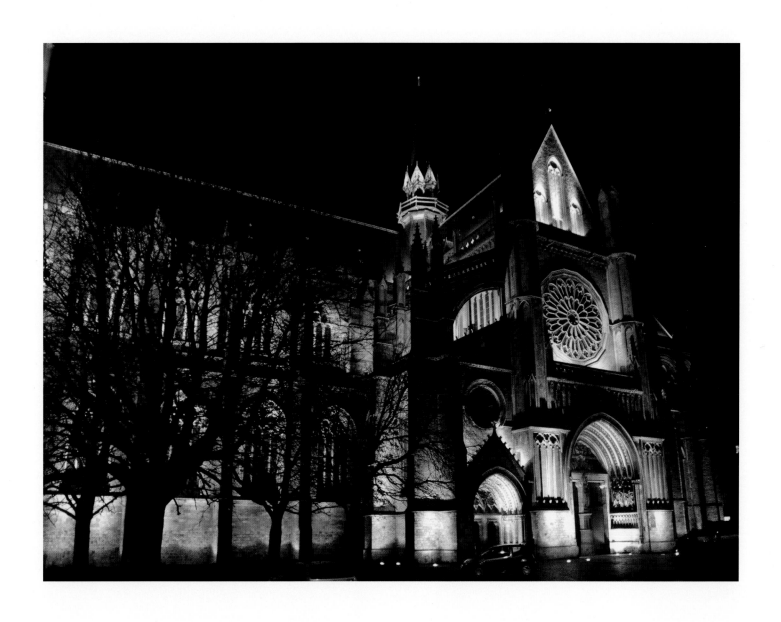

Ypres – St Martin's Cathedral.

PAGES 8–9, 10: Ypres – Cloth Hall.

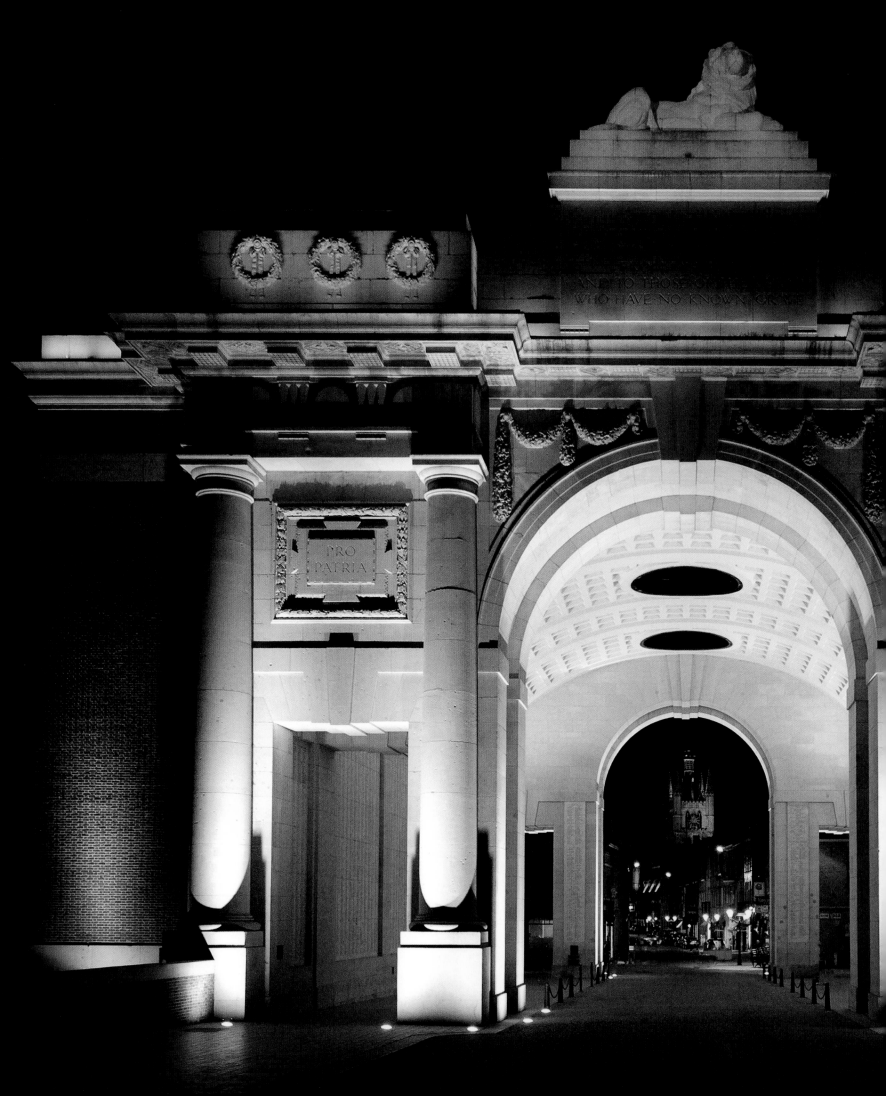

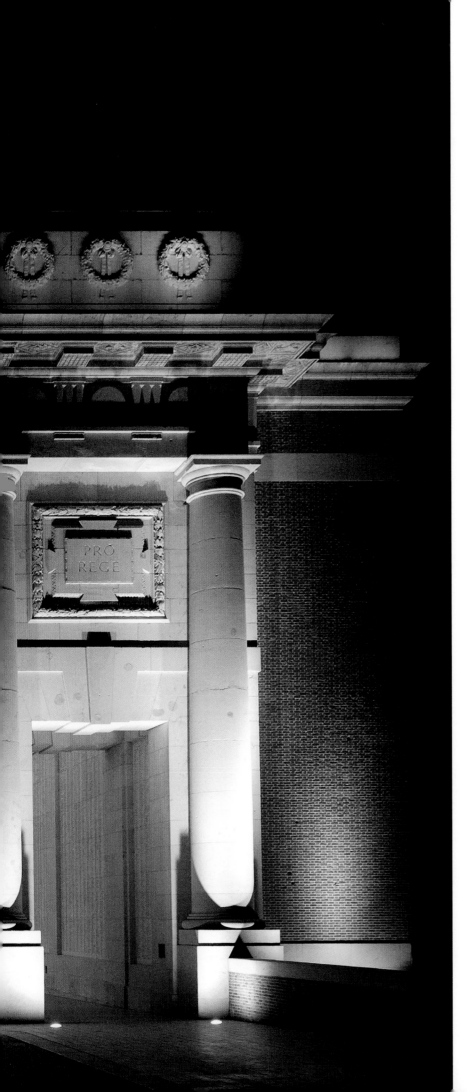

MENIN GATE

The Menin Gate is a Memorial to the Missing who died on the Ypres Salient between October 1914 and 16 August 1917, and whose graves are unknown. Sited on a main road leading from Ypres, the location was chosen as this was the point from which hundreds of thousands of men set off along the Menin Road for the front line.

Designed by Sir Reginald Blomfield, combining a classical victory arch and a mausoleum, it was inaugurated in 1927 and has 54 896 names of the missing carved into panels on its walls.

As the Gate was too small to hold the names of those who fell in the Salient after 1917 they are commemorated on the walls of the Tyne Cot Memorial, Passchendaele.

The Last Post Ceremony, which takes place every evening at 8 pm under the Menin Gate, was first held on 11 November 1929 and has continued every evening since then except during the time of the German occupation of May 1940 to September 1944.

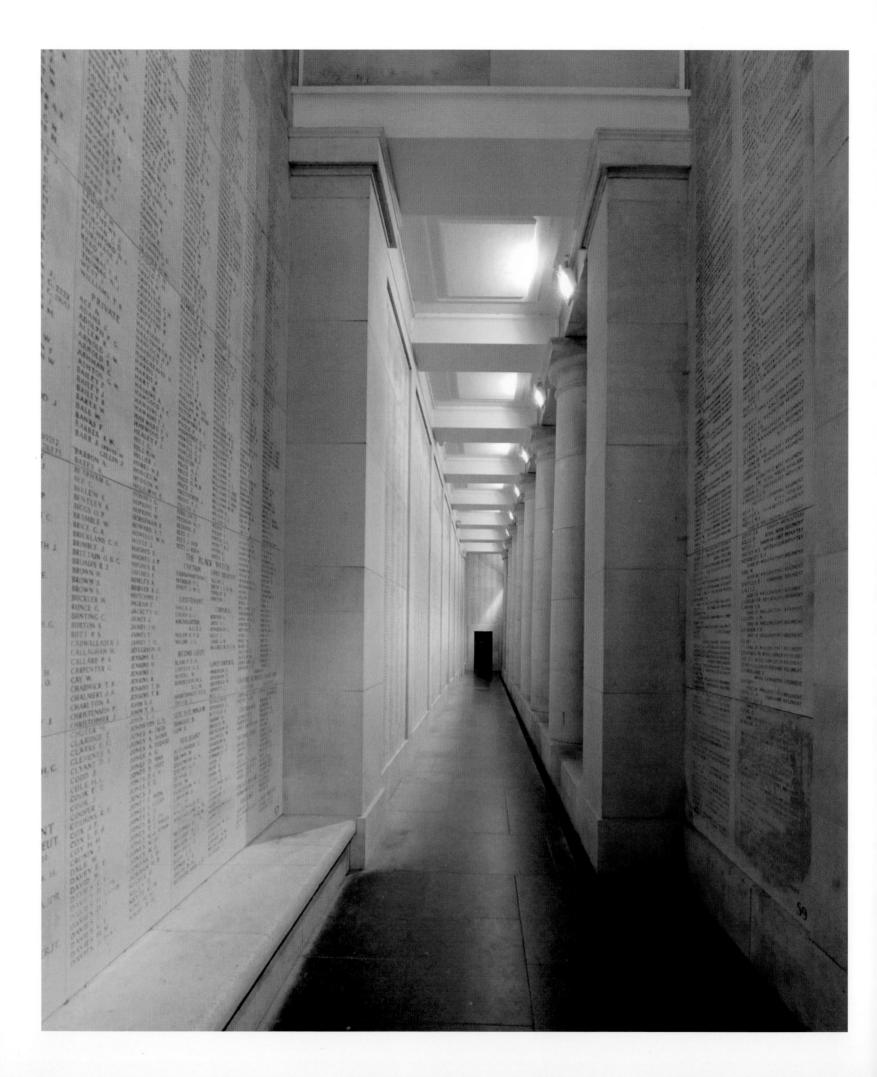

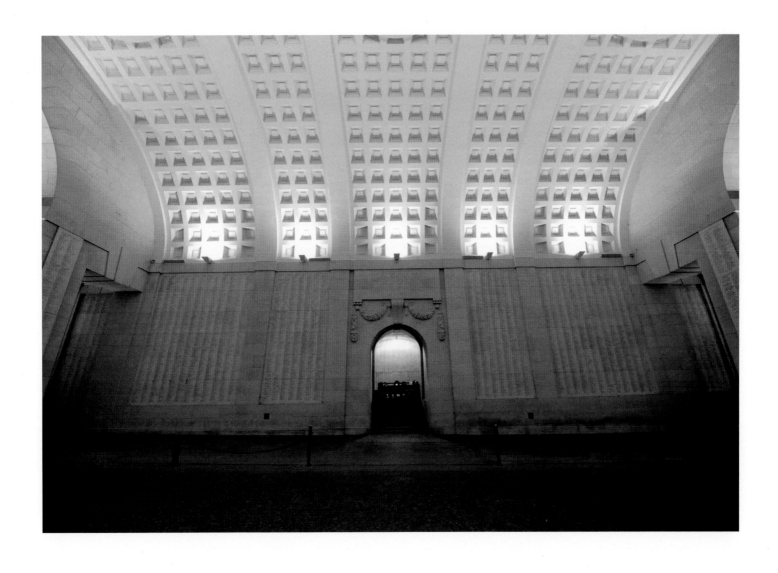

Menin Gate – central archway.

PAGE 14: Menin Gate – upper colonade.

Column 1 (left)

MURPHY A.
MURPHY J.
MURRAY J.
MURRAY J. T.
MURRAY M.
MURRAY R.
MURRAY R. E.
MUSGROVE C. A.
MYERS G. E.
NAIRN W.
NAPIER S.
NEALINGS R. W.
NELSON N.
NELSON W. E.
NEWBURY T. F.
NEWELL T. A.
NEWSOME F.
NEWSOME J. H.
NEWTON R.
NICHOL A. E.
NICHOLS J.
NICHOLSON J. 8551
NICHOLSON J. 20993
NICHOLSON R.
NIXON A.
NIXON G. H.
NOBLE A.
NOBLE C.
...GENT G.
...GENT M.
...IEN J.
...EN M.
...NNOR J.
...NELL M.
...E J. J.
...J.
...R.
T. 2071
T. 9300
...E.
...
...N W. S.
...BORN J.
...A.
...W.
...W.

Column 2

SHARKEY A.
SHARPE A.
SHAW J. E.
SHENTON J.
SHEPHERD J.
SHIELDS A.
SHINN A.
SHORTT J.
SIDDAL G. W.
SIDDLE W.
SIMMONS M.
SIMPSON J.
SIMPSON T.
SIMPSON W.
SKELTON R.
SKIDMORE G.
SLACK B.
SLEE J. J.
SMAILES C.
SMAILES W. W.
SMALL H.
SMITH D.
SMITH E.
SMITH E. G.
SMITH E. L.
SMITH H.
SMITH H. F.
SMITH J. 1079
SMITH J. 1185
SMITH J. 4030
SMITH J. 8597
SMITH J. W.
SMITH L. A.
SMITH R.
SMITHAM G. W.
SMYTHE R.
SNOWDEN T. G.
SNOWDON H.
SOULSBY W.
SOUTER J.
SPEARS S.
SPEDDING M.
SPENCE W. B.
SPENCER J. E.
SPENCER J. H.
SPENCER S. O.
SPROATE A.
STAMPER H. S.
STANFORD W. W. H.
STANLEY J.
STANLEY J. J.
STANSFIELD W.
STEPHENSON F.
STEWART W.
STOBBART M.
STONEHOUSE T.
STOREY D.
STOREY G. L.
STRAKER J. T.
STURGEON T. W.

Column 3

COY. SJT. MAJOR
HOSKINS H.
LUCAS B. M.M.

COY. QMR. SERJT.
JONES W.
MONTGOMERY P. T.
 D.C.M.

SERJEANT
BUCKLEY T.
CHARLES A. E.
CLINTON J. T.
CRANBROOK W.
GARVEY J. A. G.
GATELEY J.
HICKS O. J.
HOLDEN H. H. B.
JEYNES E. T.
LUCKMAN W.
MORTON A.
PALMER F. S.
REEVES S. A.
SKIDMORE W. H.
SMITH H.
STURT N. H.
TODD E.
WEST T.
WOODING F. C.

LANCE SERJEANT
BANNARD B. C.
BICKLEY A.
MULLISS S.
O'CALLAGHAN J. M.

CORPORAL
BRUSH A.
BURTON H.
COSFORD G.
JACQUES W.
MOORE A.
MURPHY S. J.
NORMAN W. J. P.
PARRY A.
REDFERN J. W.
SEARLES J.
SMITH J. T.
TURNER W. P.
WILLETTS G.
YATES T.

LANCE CORPORAL
ADAMS W. H.
BAKER J.
BENSON W. E.
BOOTH R.
BULLOCK T. W.
BURROW T.
BUTLER W. E.
CLEAVER A. H.
CLIFFORD N.
COLLINS J. L.
CRESSWELL S. W.
DAVY R. P.
DENBY W.
DENNIS H.

Column 4

PRIVATE
ADAMS H.
ANDREWS G.
ANDREWS J.
ARNFIELD G.
ASSINDER C. W.
ASTELL B. T.
AUKIN A.
AUSTIN A.
BACON J.
BAILEY C. W.
BAKER F. P.
BAKER T.
BALDWIN G. D.
BALL A.
BALLARD E.
BAMFORD J. P.
BARCLAY A.
BAREFOOT C. H.
BARLEY F.
BARNETT E. W.
BARNETT C. J.
BARRATT I.
BASTABLE W. H.
BATSFORD W.
BATTIN C.
BAUGH J.
BAYLISS F.
BAYLISS H.
BEACH C. T.
BEALE J. A.
BEAUFOY B.
BEESLEY G. L.
BEESLEY J. E.
BEMBRIDGE H.
BENJAMIN H. W.
BIFFIN A. S.
BILKE B.
BIRD G. A.
BIRD J.
BLICK W. J.
BONEHILL D.
BONNER B.
BOSWORTH W.
BOULTON S. J.
BOUSFIELD S. R.
BOXWELL A. F.
BRACEY F.
BRADBURY E.
BRADSHAW A.
BRADSHAW L.
BRIMBLE R.
BROADFIELD O.
BROWN B.
BROWN G.
BROWN G. F.
BROWN H.
BUCKLEY J. U.
BURDEN O.
BUTLER M.
BYRON J.
CADMORE J. S.
CARTER G. H.
CASSELL J.
CHARLWOOD J. H.
CHATLAND W. G.
CHATMAN F. H.
CHERRY A.
CHILD J.
CLARKE J. W.
CLARKE W. J.
CLAY E. A.
CLEMENS J.
CLEMENTS T.
CLETON J.
CLEWS L.
CLISSETT W. F.
COATES F.
COATES J.
COBB G. H.
COCKERILL G.
COLLINS C.
CONNOR J.
COOK C. A.

Column 5

PRIVATE
COLBORN G.
COOK G. W.
COWAN W. J.
CROSHAW E.
CURLEY A.
DAVID A.
FALLON J.
FANTHAM J.
FEIST S.
FISHER W.
FLETCHER W. A.
FODEN H. H.
FOSTER J.
FOX C.
FRASER G. B.
FREEMAN H.
GAHAN J.
GALLOWAY J.
GARDNER J. T.
GARLAND J.
GARLAND W. E.
GARTENFIELD C. R.
GARVEY W. H.
GEAR C. J.
GIBSON A.
GIFFORD W. H.
GILBERT J.
GILBERT O. J.
GILDERSON W. C.
GODRIDGE J.
GOLDING H. J.
GOODCHILD J. A.
GOODFIELD C.
GOODWIN A.
GOODYEAR J.
GORDON W. P.
GOUGH B. G.
GOVETT A. B.
GRAY W. C. H. E.
GREATRIX W.
GREENING A.
GREENWAY E. W.
GRIFFIN A.
GRIFFITHS A.
GRIFFITHS H.
HALL C.
HALL H.
HAMMOND J.
HANCOX C. J.
HANSON C.
HARRIS W. C.
HART J. T.
HASTINGS J. C.
HATELEY S.
HAWKES F. G.
HAYWOOD W.
HEAD A. W.
HEALEY J. T.
HEWITT G.
HIGGERSON A.
HILL A. J.
HILL G. J.
HILL H.
HILLIER J.
HIRST E. G.
HODGKINSON
HOOKER H.
HOPSTON F.
HUBBALL A.
HUGHES F.
INGRAM F.
INGRAM W.
IRELAND
JACKA C.
JELF J.
JONES

Column 6 (right, partial)

THE ROYAL
LIEUT COLONEL
BIRCHALL

CAPTAIN
BURDETT
CURWEN
DAY F. C.
DE TRAF...
DOUDNE...
FORST...
FRIED...
FULL...
GRAY...
HAR...
HOD...
MO...
PU...
T...

ROBERTS C. J.
ROBINSON W.
ROCHESTER C.
RODDS F.
ROONEY W.
ROWLEY J. S.
RYAN J. M.
SAVILLS.
SAVAGE J. P.
SAWYER A.
SELBY W.
...
JONES
JONES
JONES
JONES
JORIN
KEL...
KEL...
KIL...
KI...

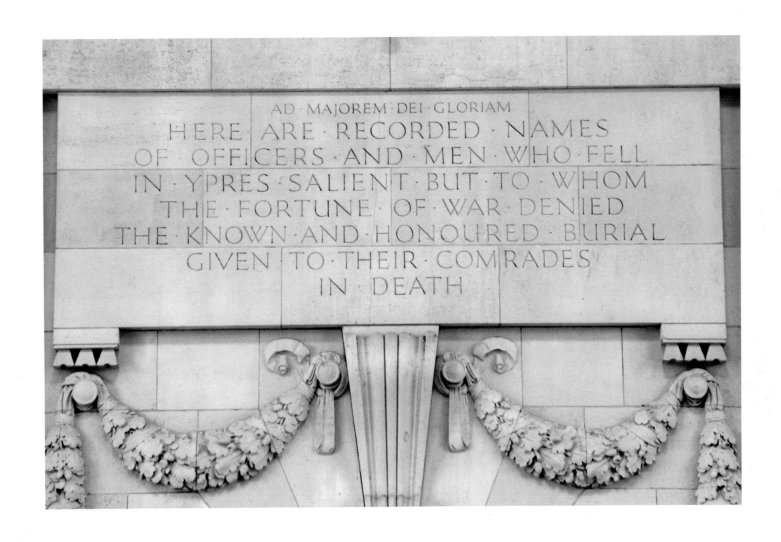

Menin Gate Memorial.

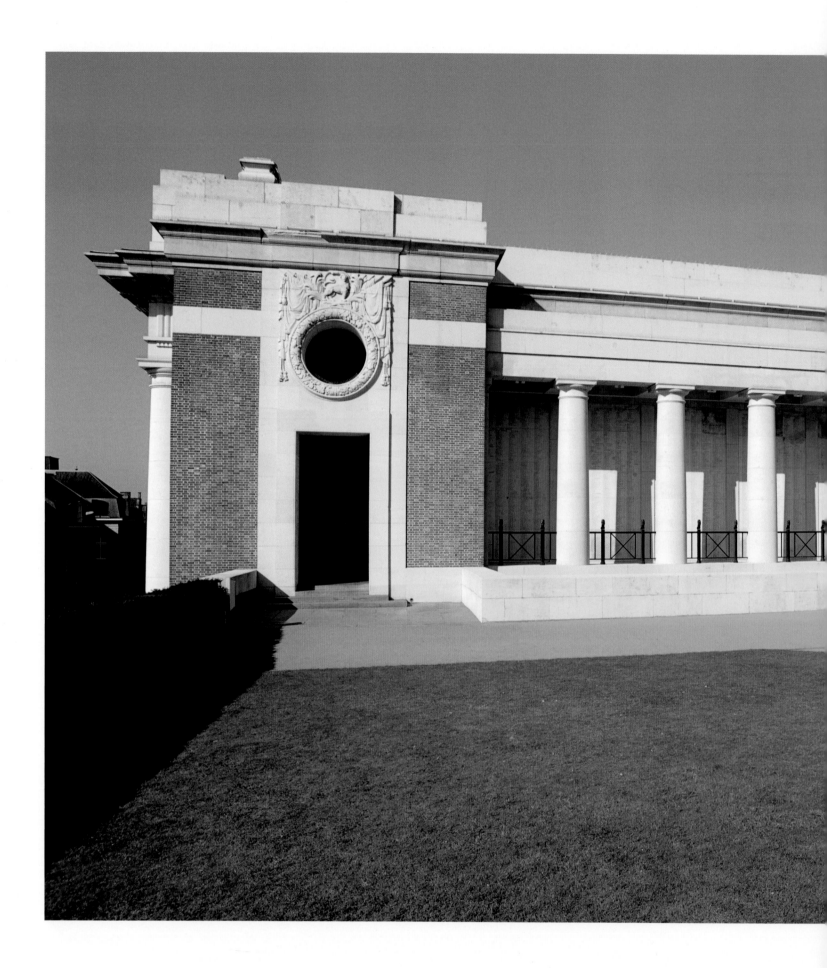

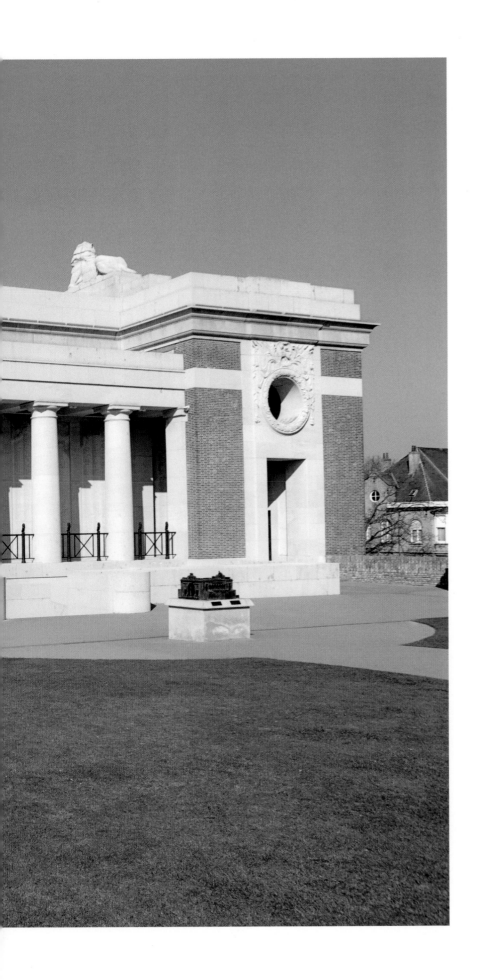

Menin Gate Memorial – North façade.

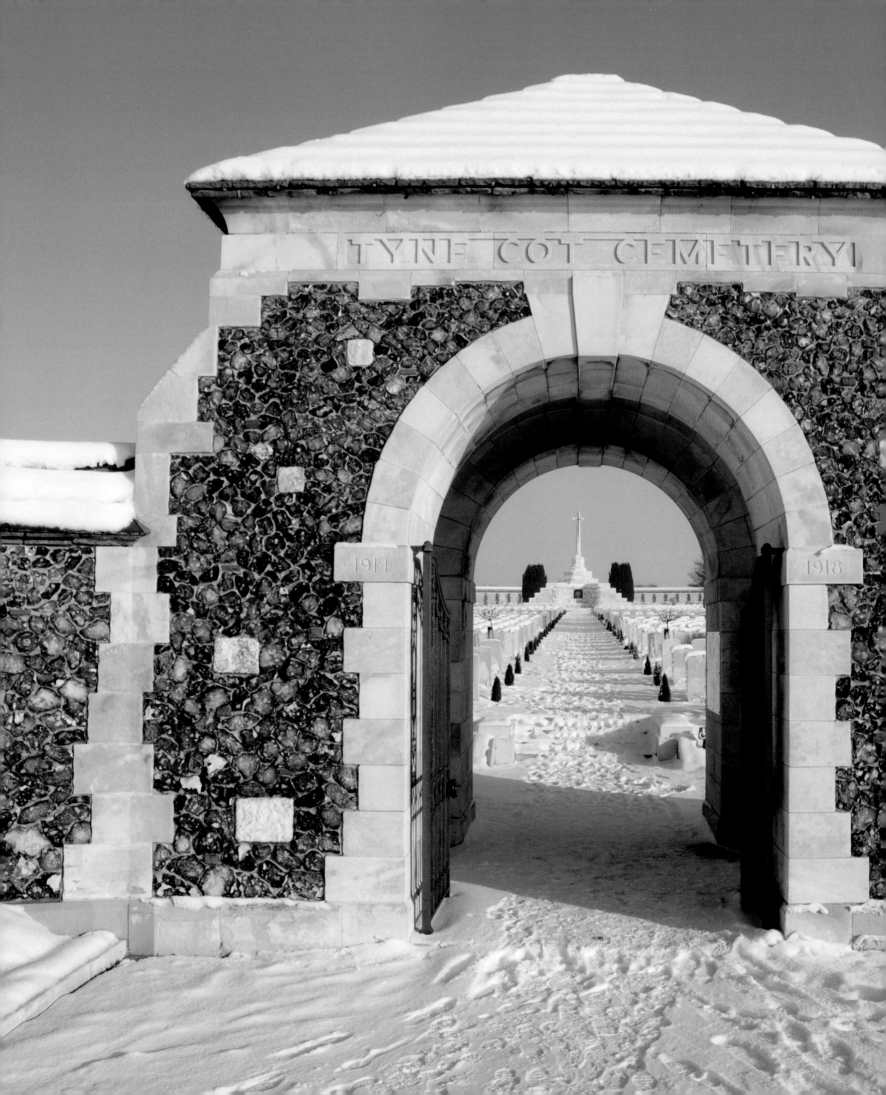

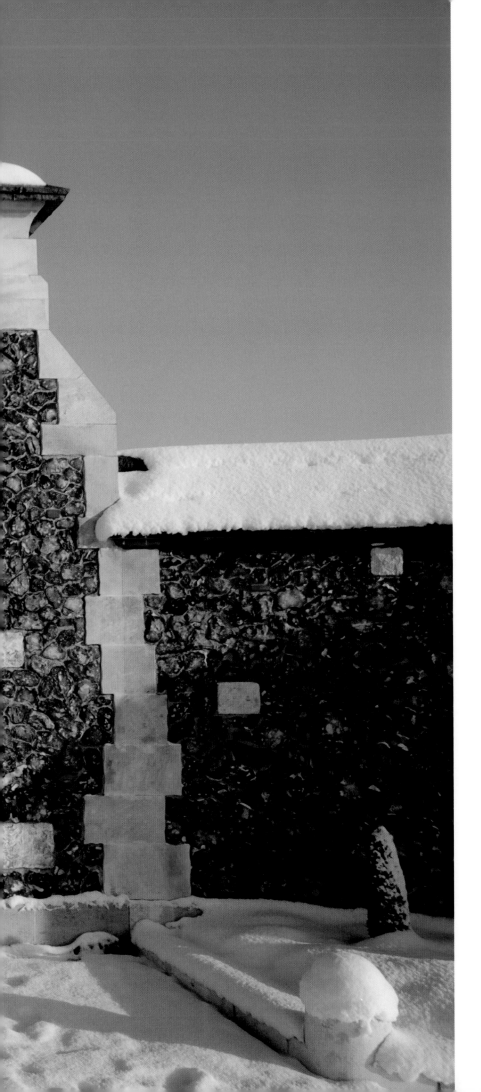

TYNE COT CEMETERY

Tyne Cot is the largest of the cemeteries on the Western Front, containing 11 953 graves with a further 34 870 names of the missing recorded on the Tyne Cot Memorial that forms the far wall of the cemetery.

Designed by Sir Herbert Baker, it encloses the remains of three German blockhouses. A pill box forms the foundation for the Cross of Sacrifice and part of it can still be seen bearing the inscription:

This was the Tyne Cot Blockhouse
captured by the 3rd Australian Division
4th October 1917

Nowhere is the title of this book more aptly illustrated than on pages 22–23 where row upon row of headstones are seen lined up like a regiment on parade – a regiment of the dead.

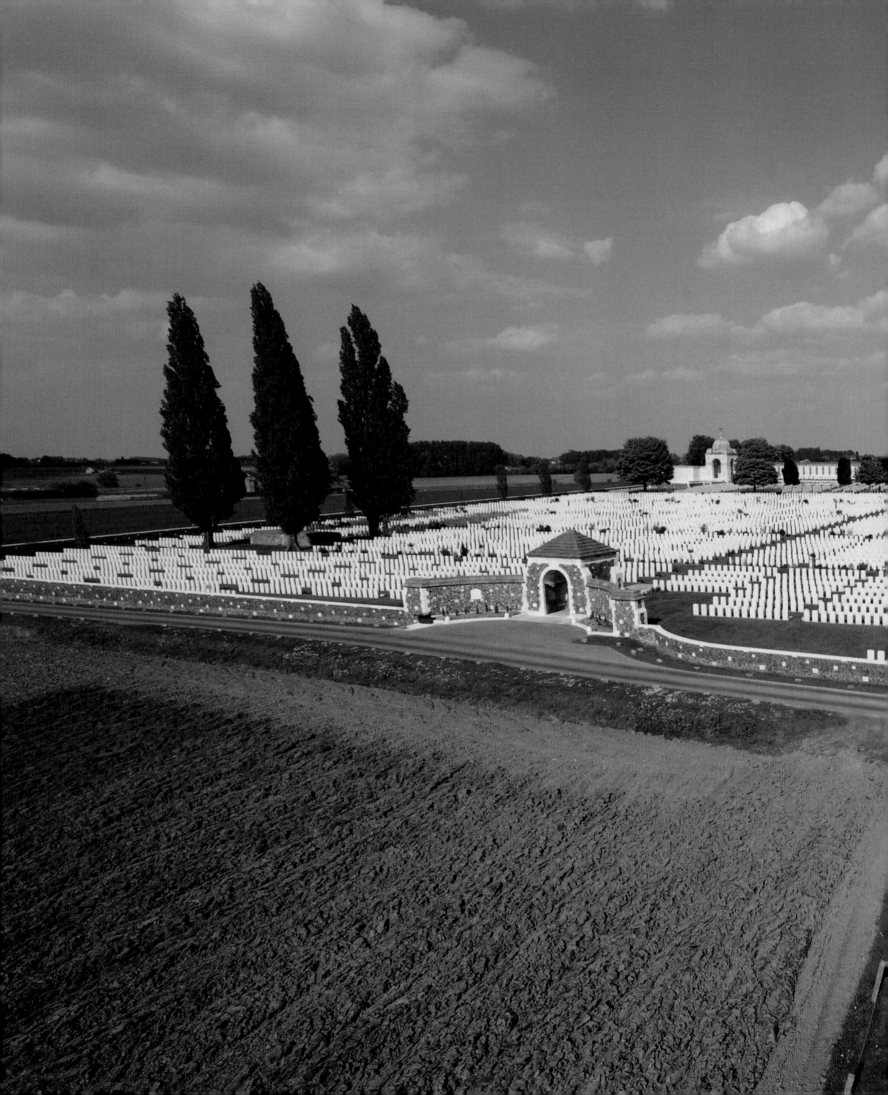

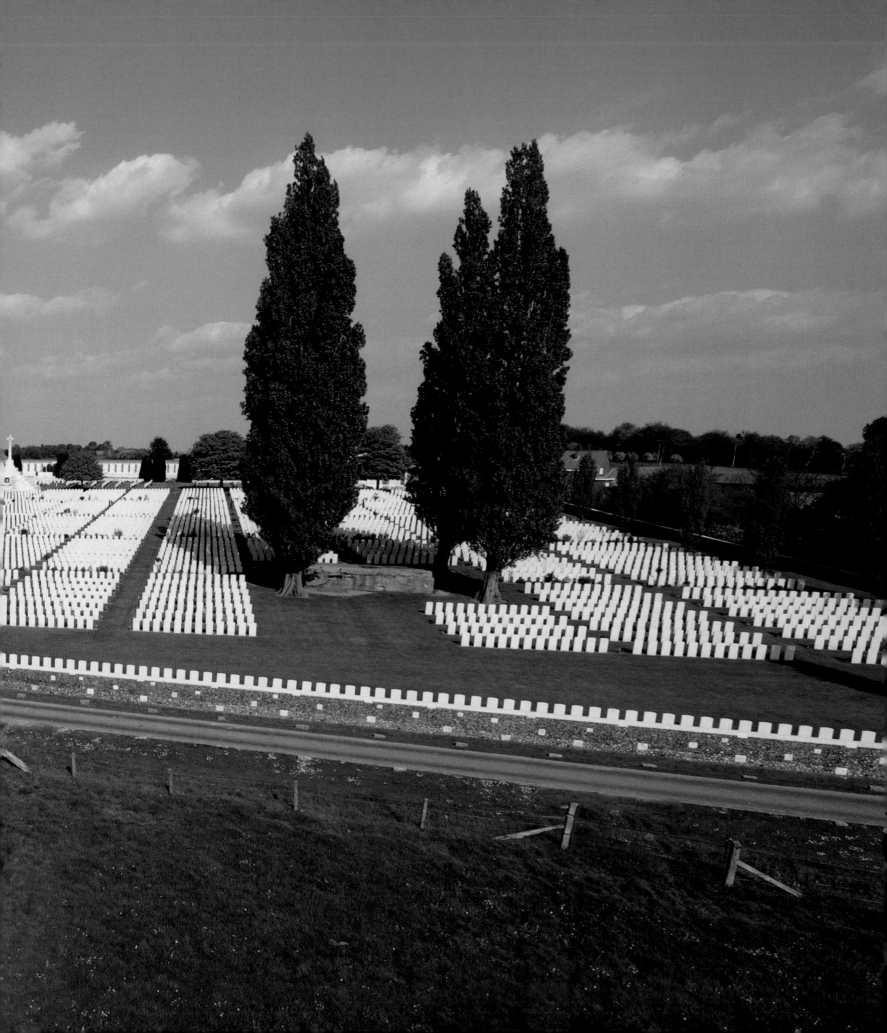

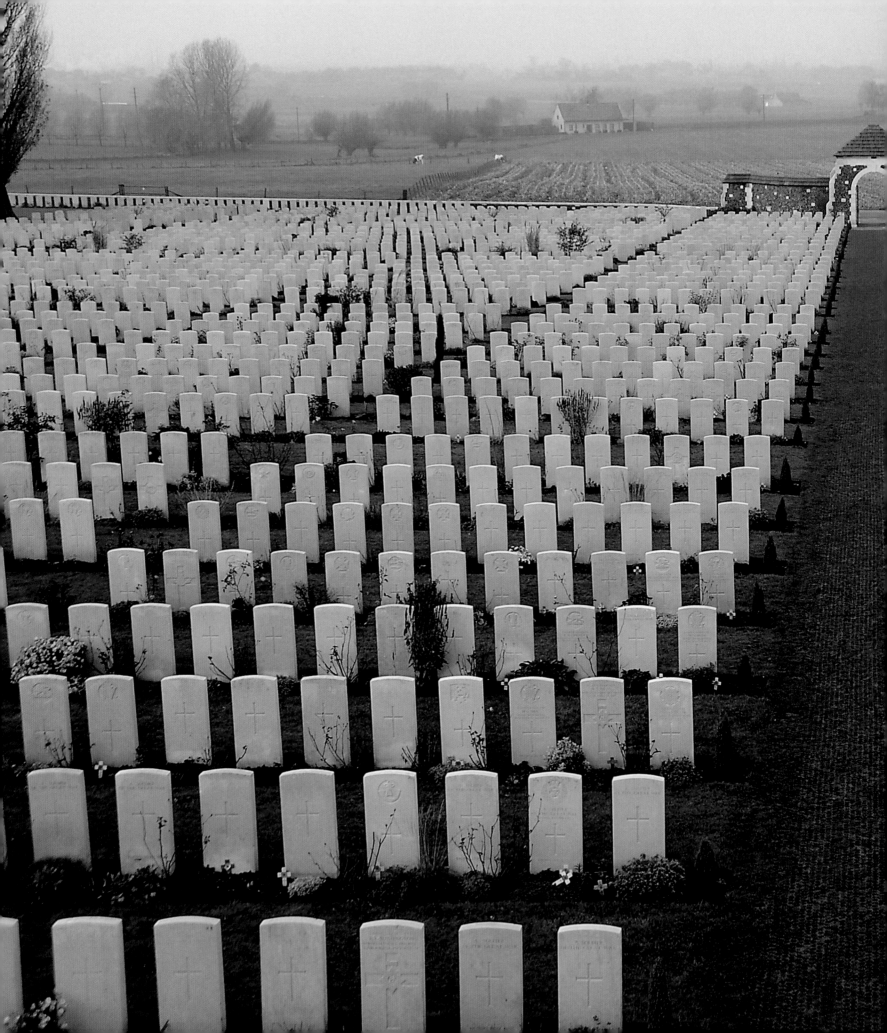

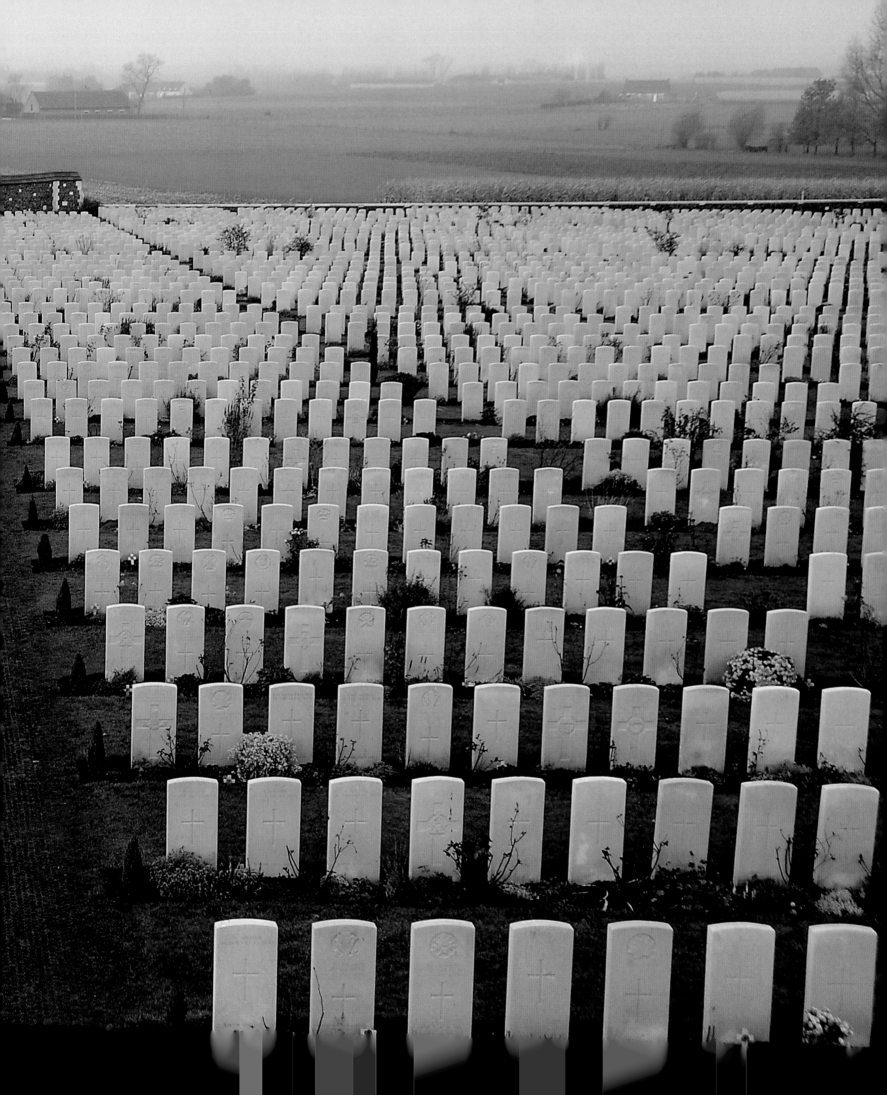

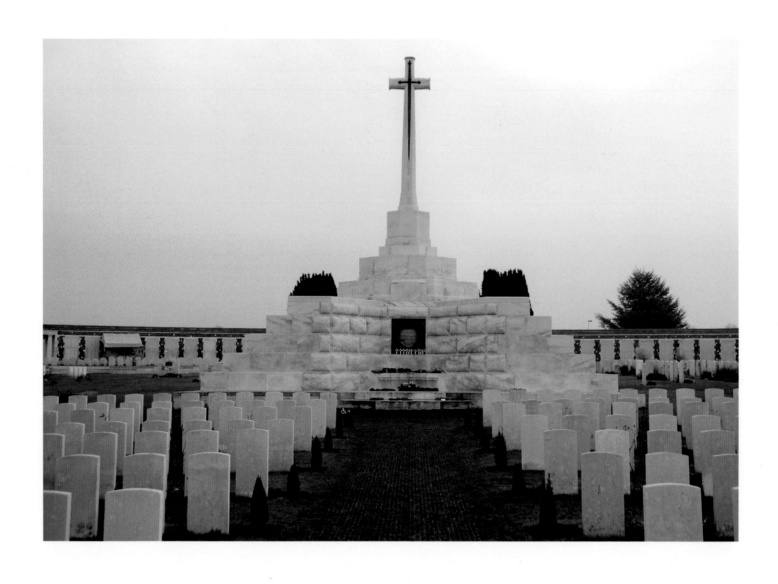

Tyne Cot Cemetery.

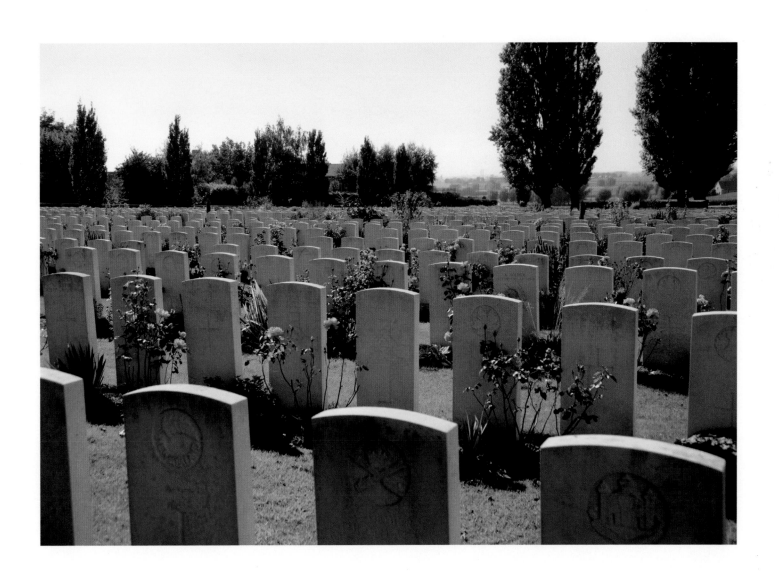

Tyne Cot Cemetery.

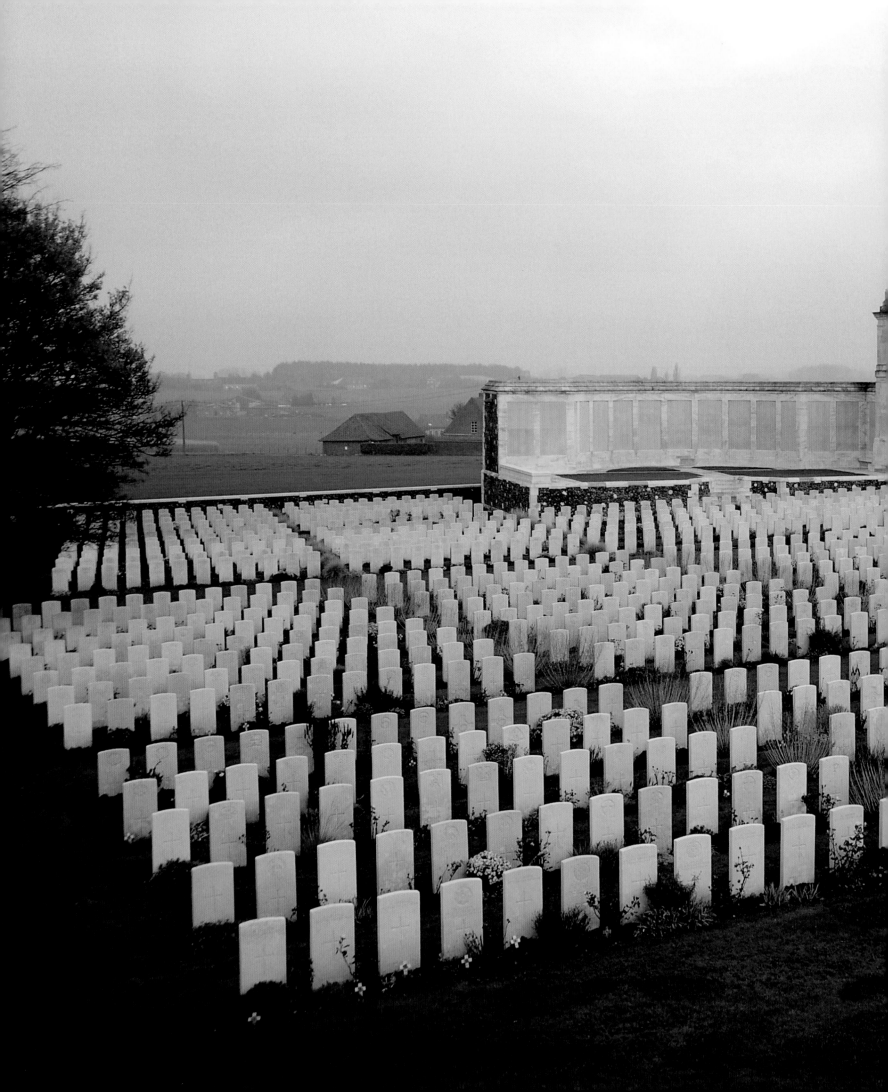

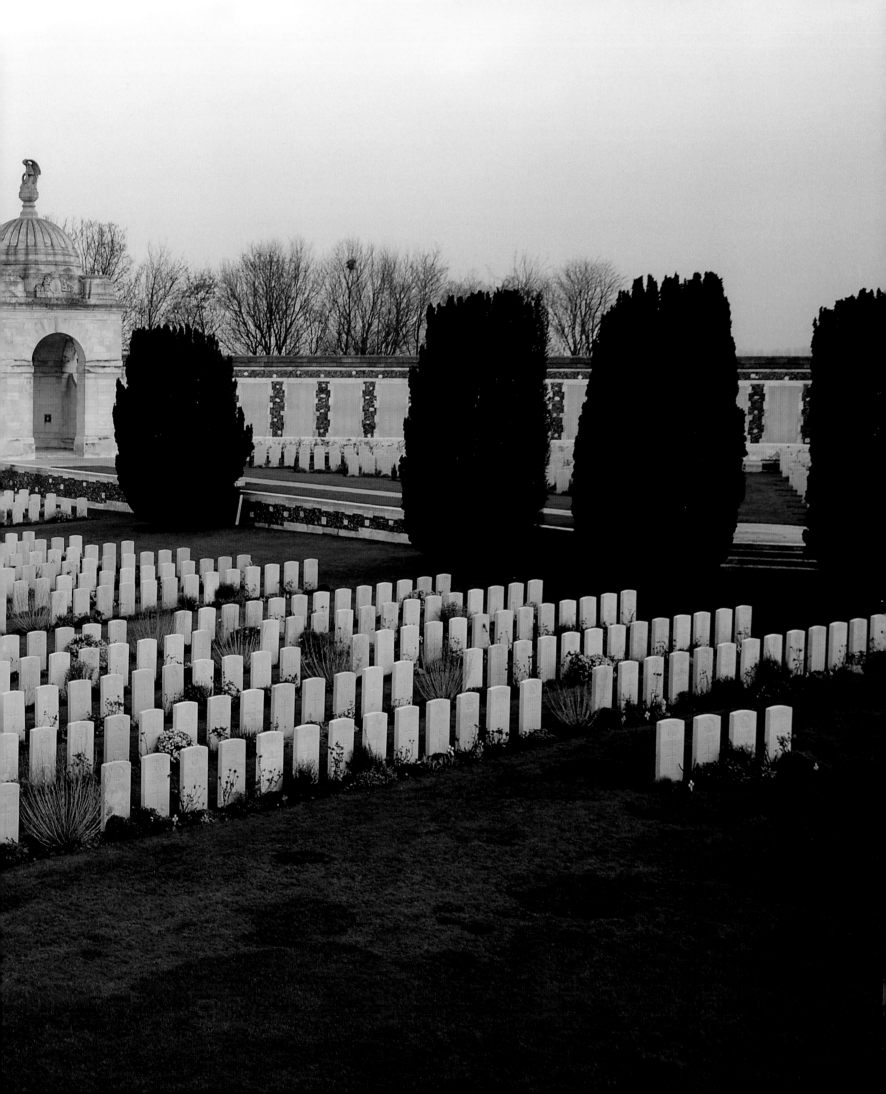

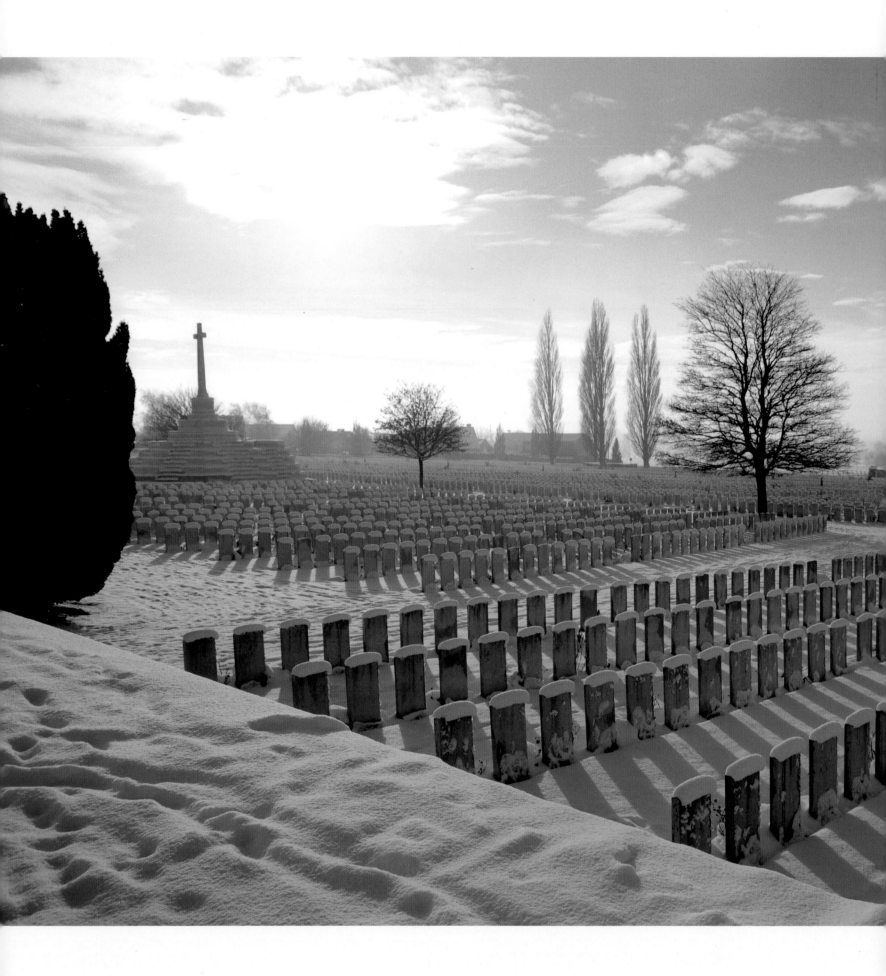

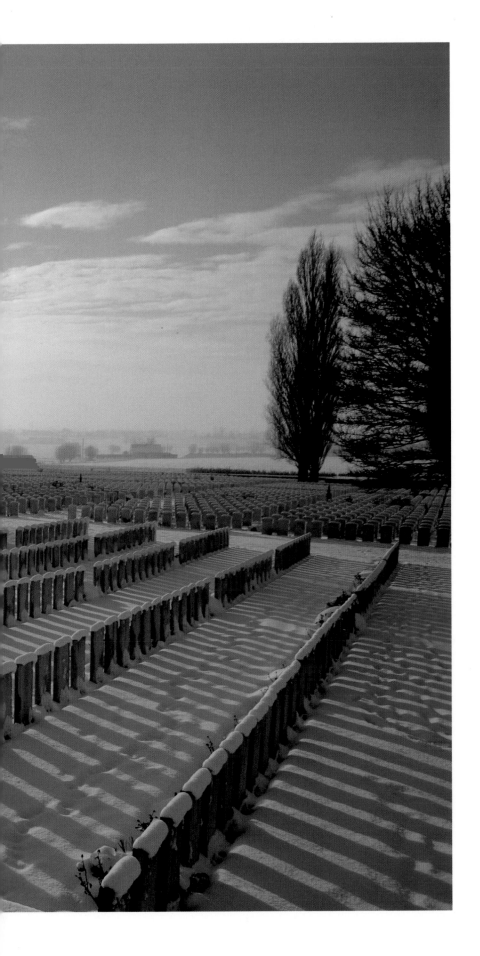

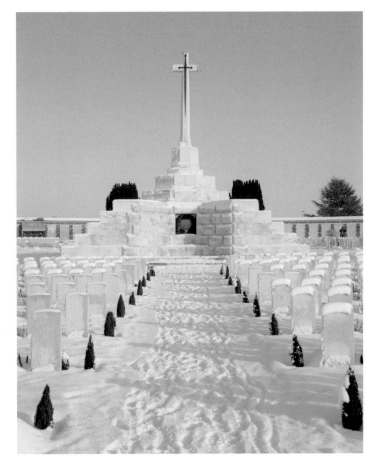

PAGES 28–33: Tyne Cot Cemetery.

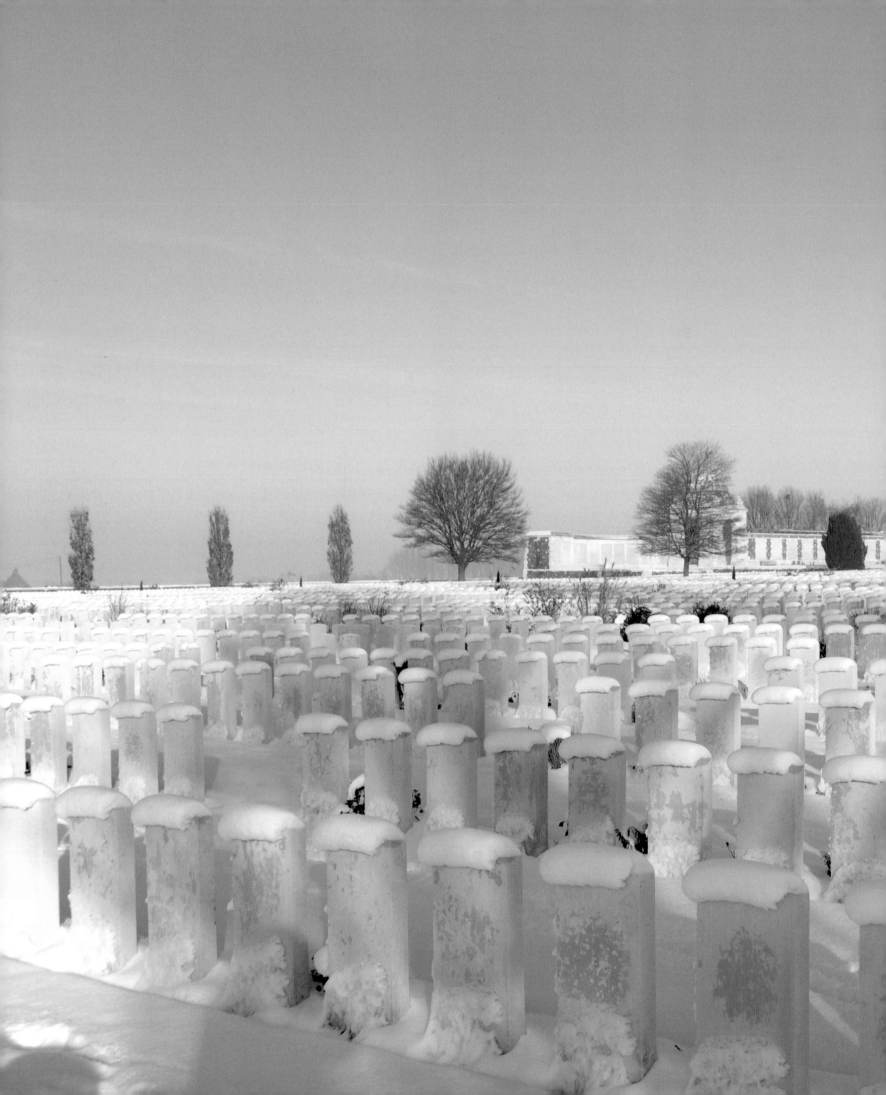

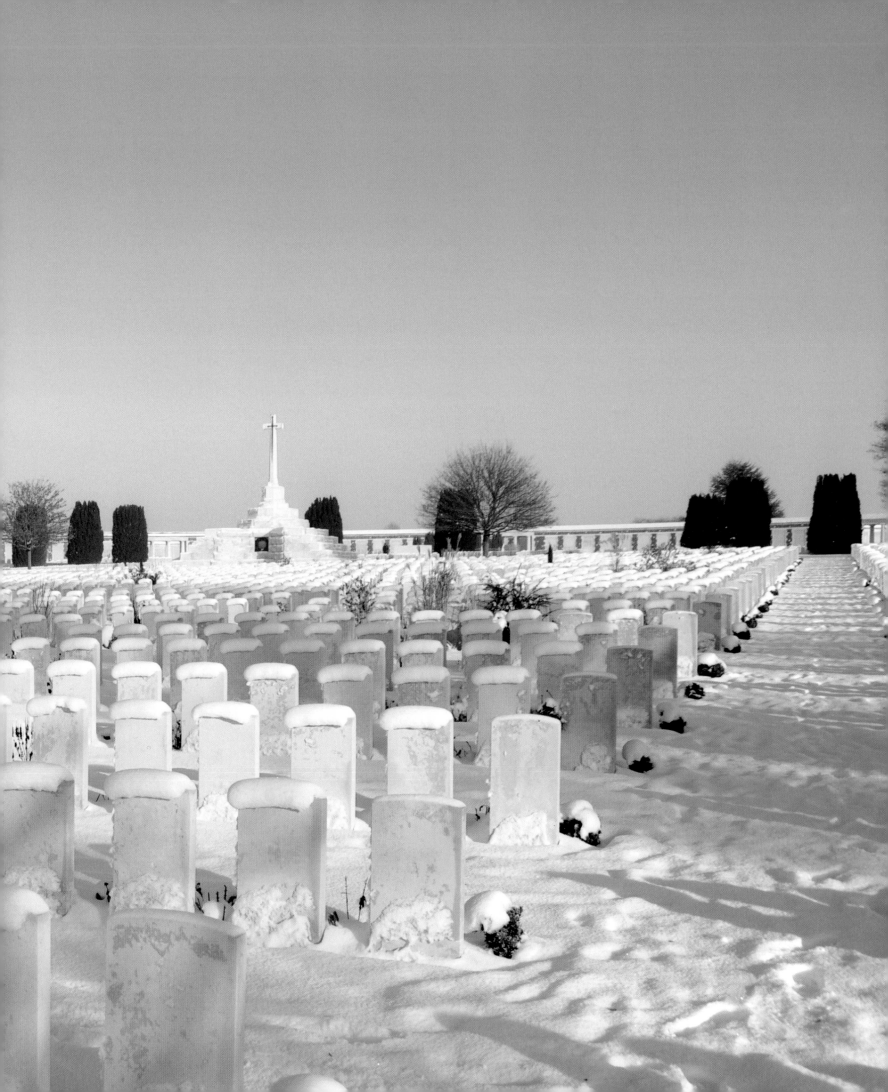

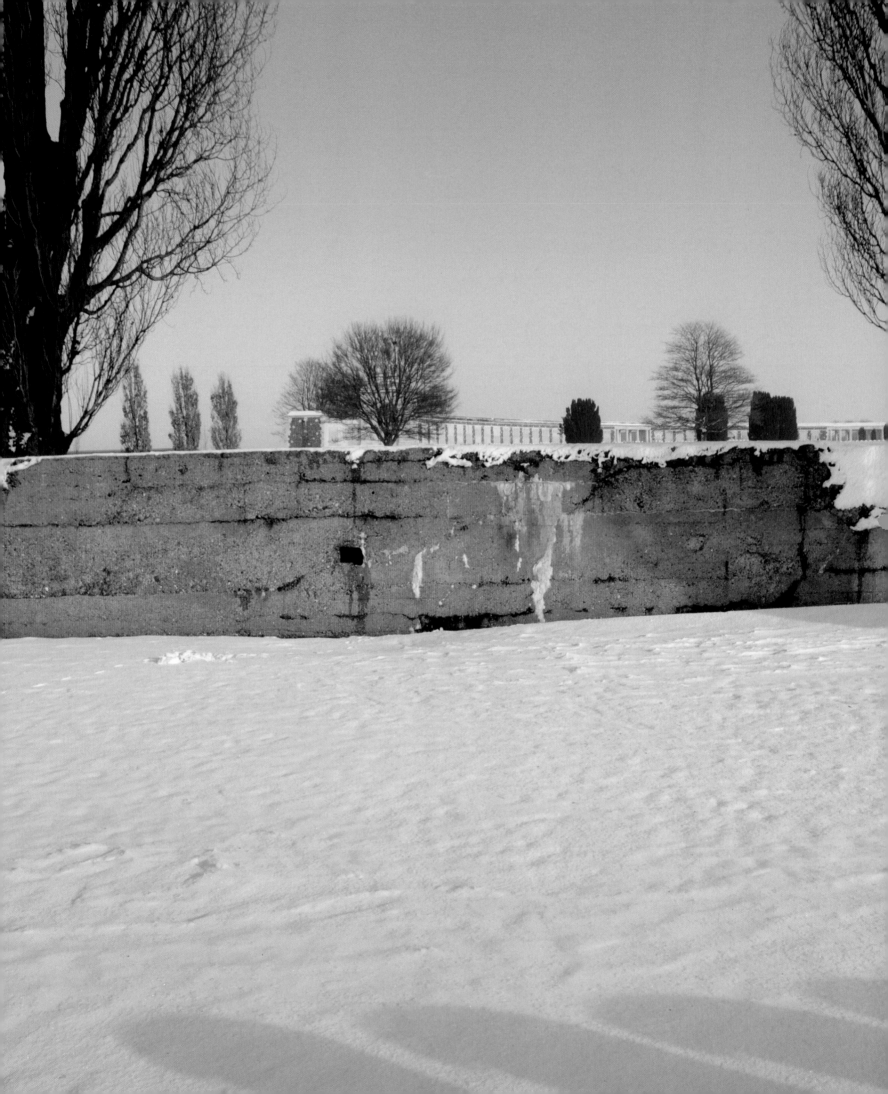

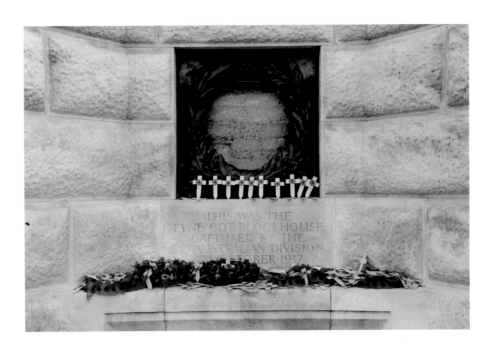

Inscription at the base of the Cross of Sacrifice.

PAGES 34, 36, 37: Tyne Cot Cemetery.

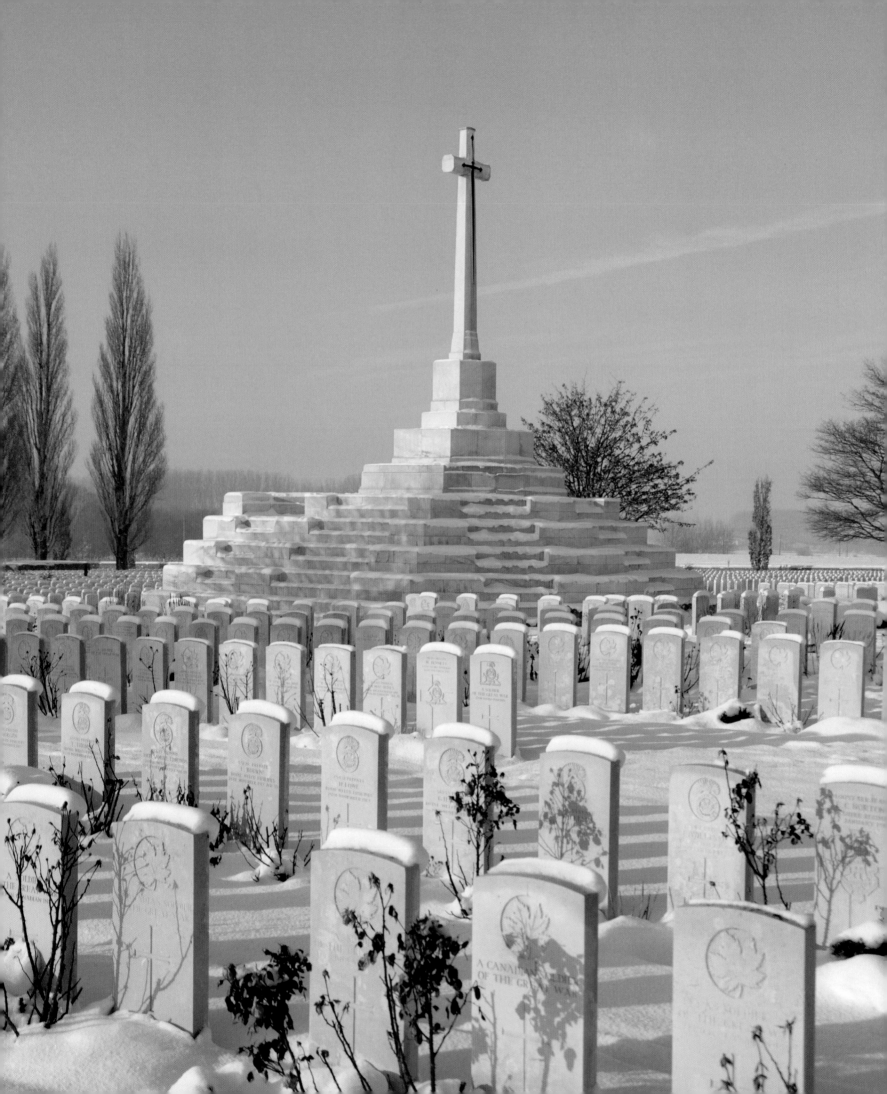

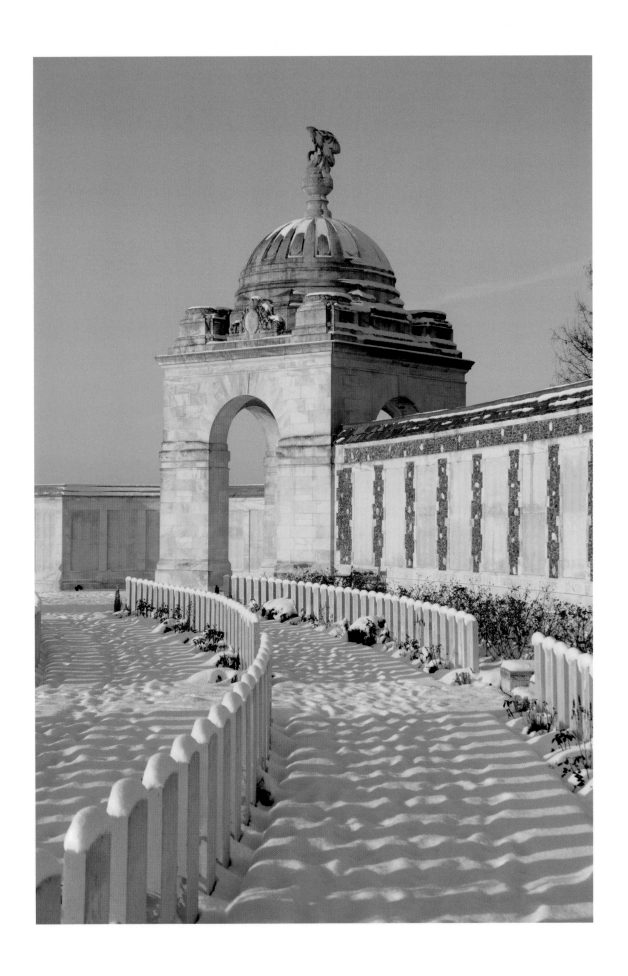

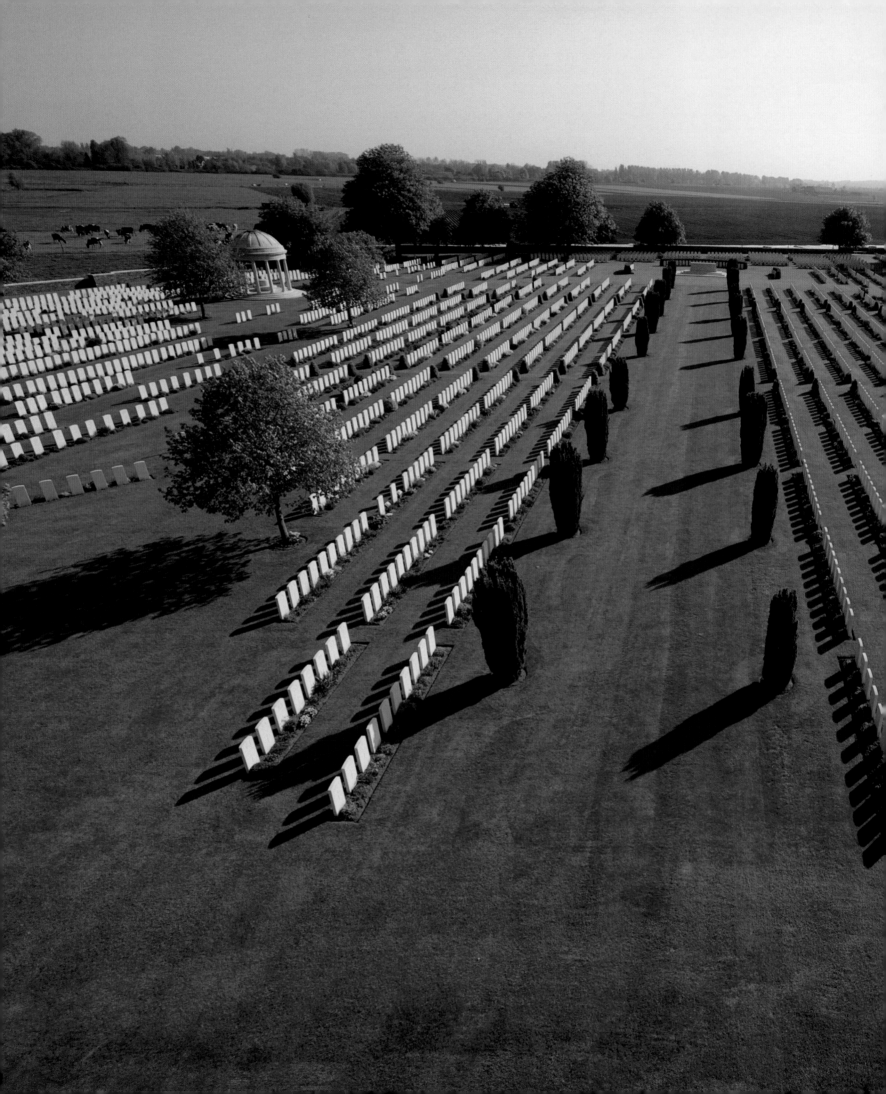

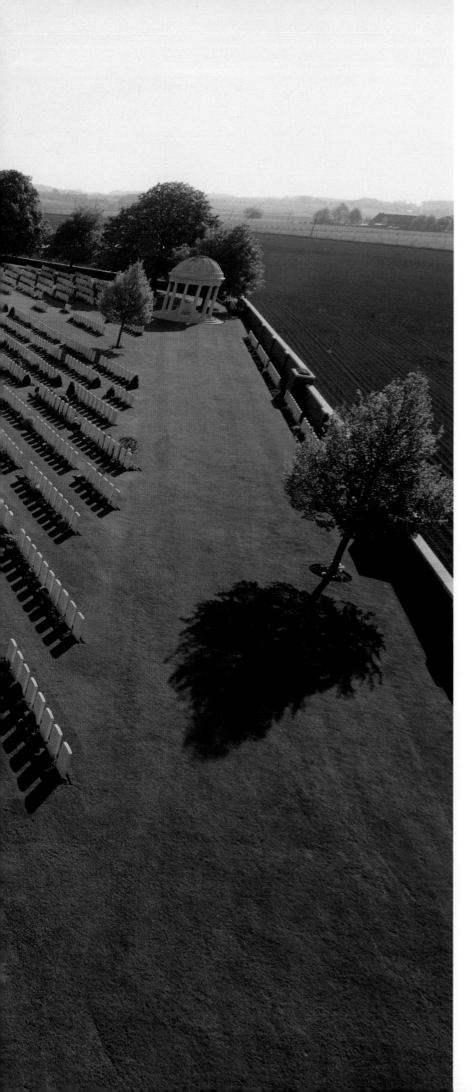

BEDFORD HOUSE
CEMETERY

Originally the site of the Château Rosendal, with a lake, woodland and moats, it was re-named by the British, Bedford House, and used as a headquarters. During the course of the war the house and grounds were shelled extensively and destroyed.

This cemetery, consisting of four enclosures, now contains 5 075 burials of bodies found over the Salient after the war. An additional 69 servicemen of the British Expeditionary Force killed in the defence of the Ypres-Comines canal and railway during the evacuation to Dunkirk in May 1940 are also interred here (see semi-circular graves on pages 44–45).

Designed by Wilfred Clement Von Berg, assistant architect to the Imperial War Graves Commission, the cemetery incorporates the old moats that were part of the château grounds, and some stepping stones are the only remnants of the house.

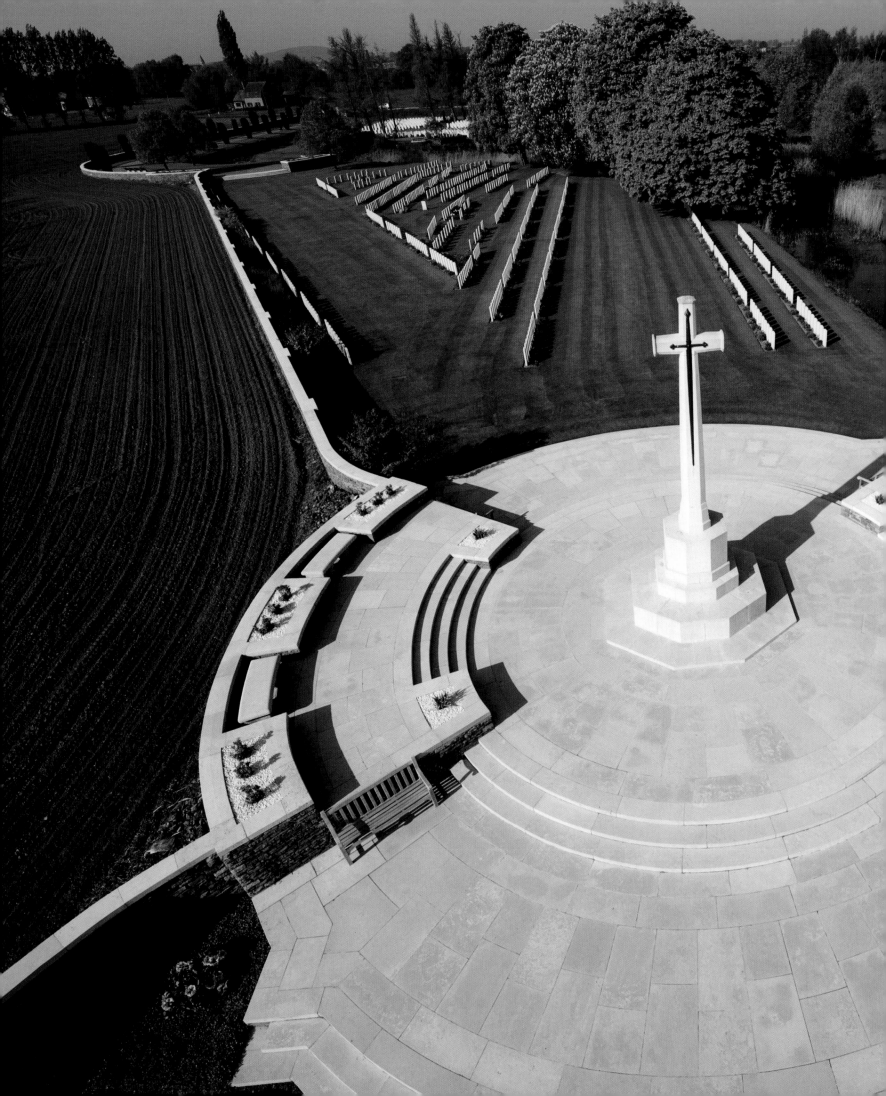

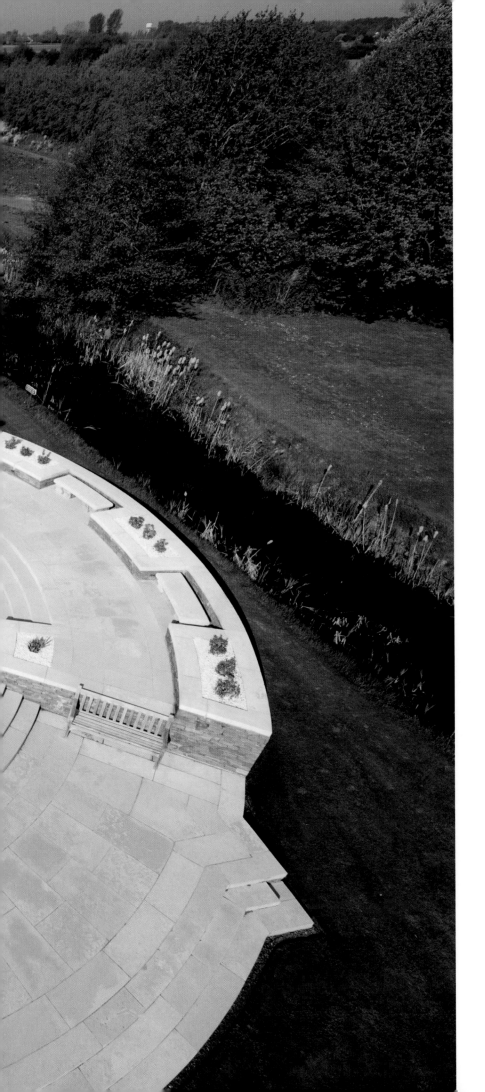

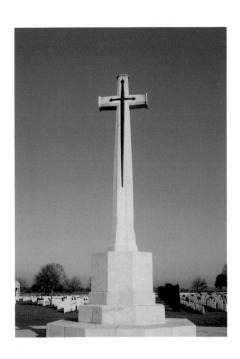

Cross of Sacrifice.
PAGES 40–47: Bedford House Cemetery.

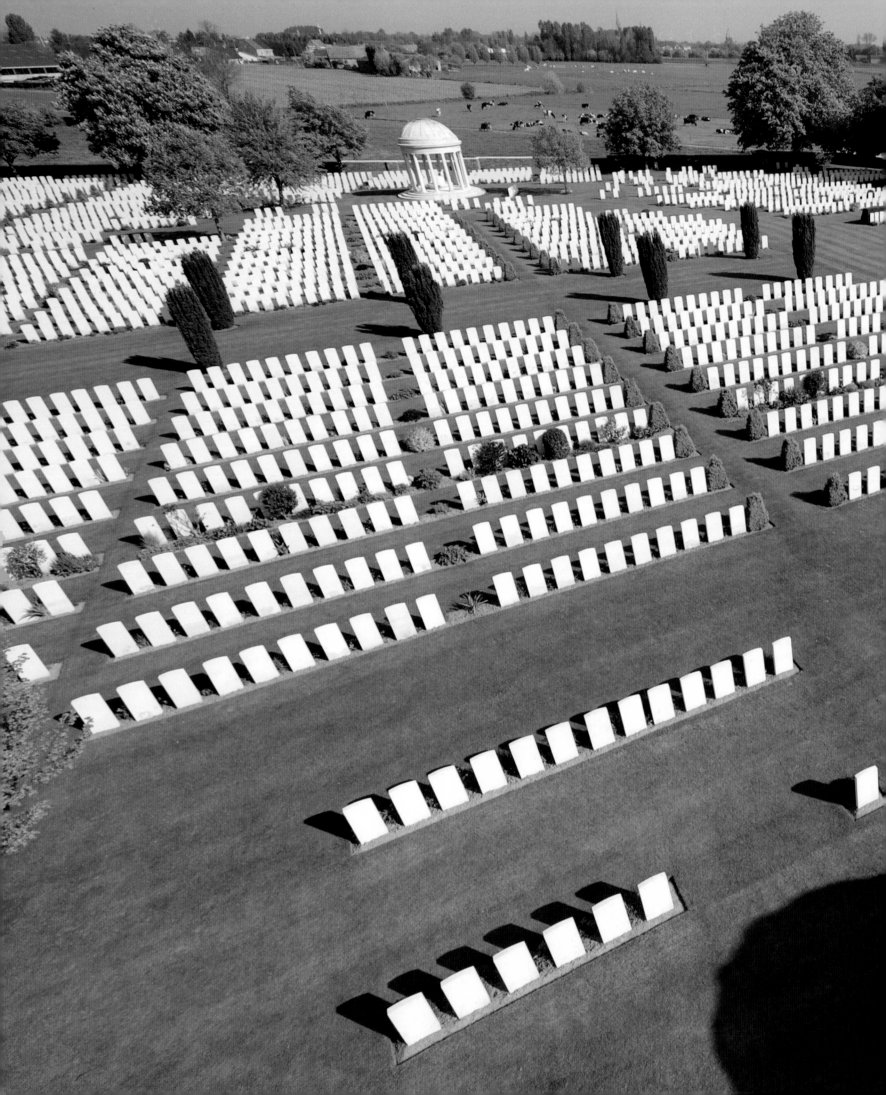

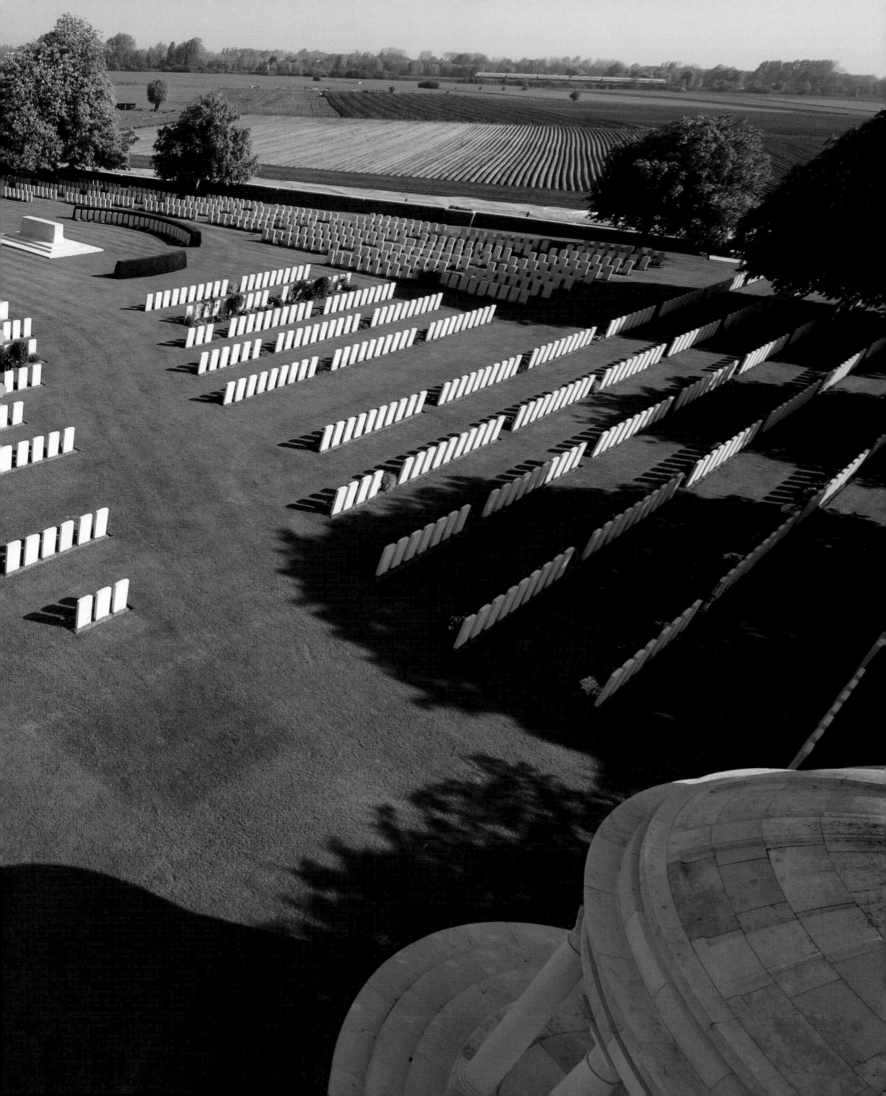

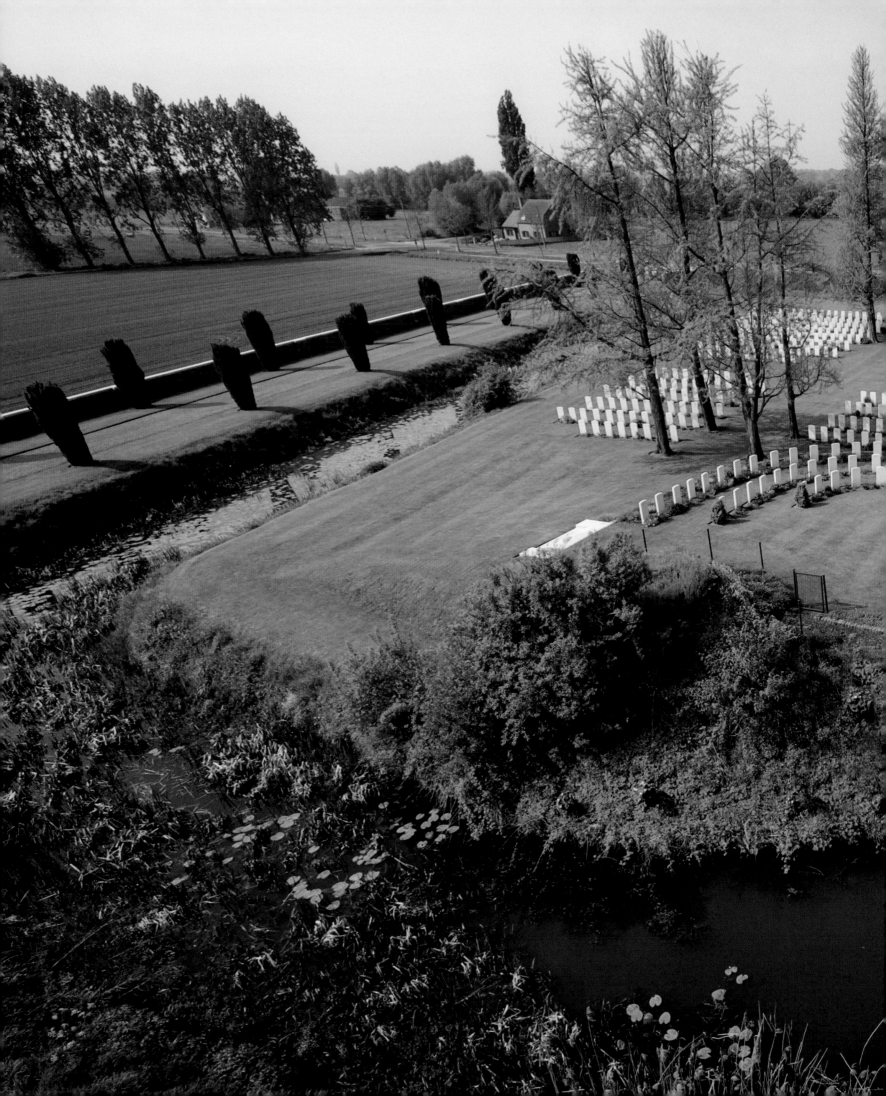

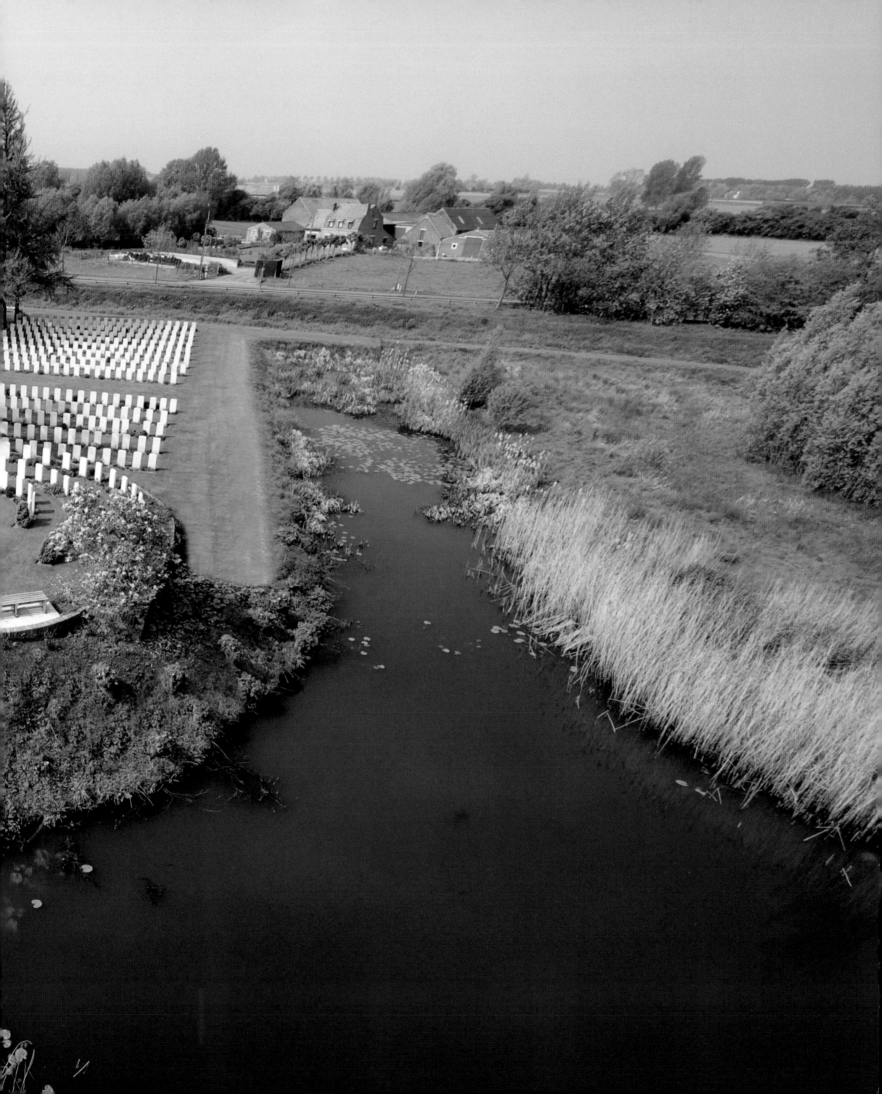

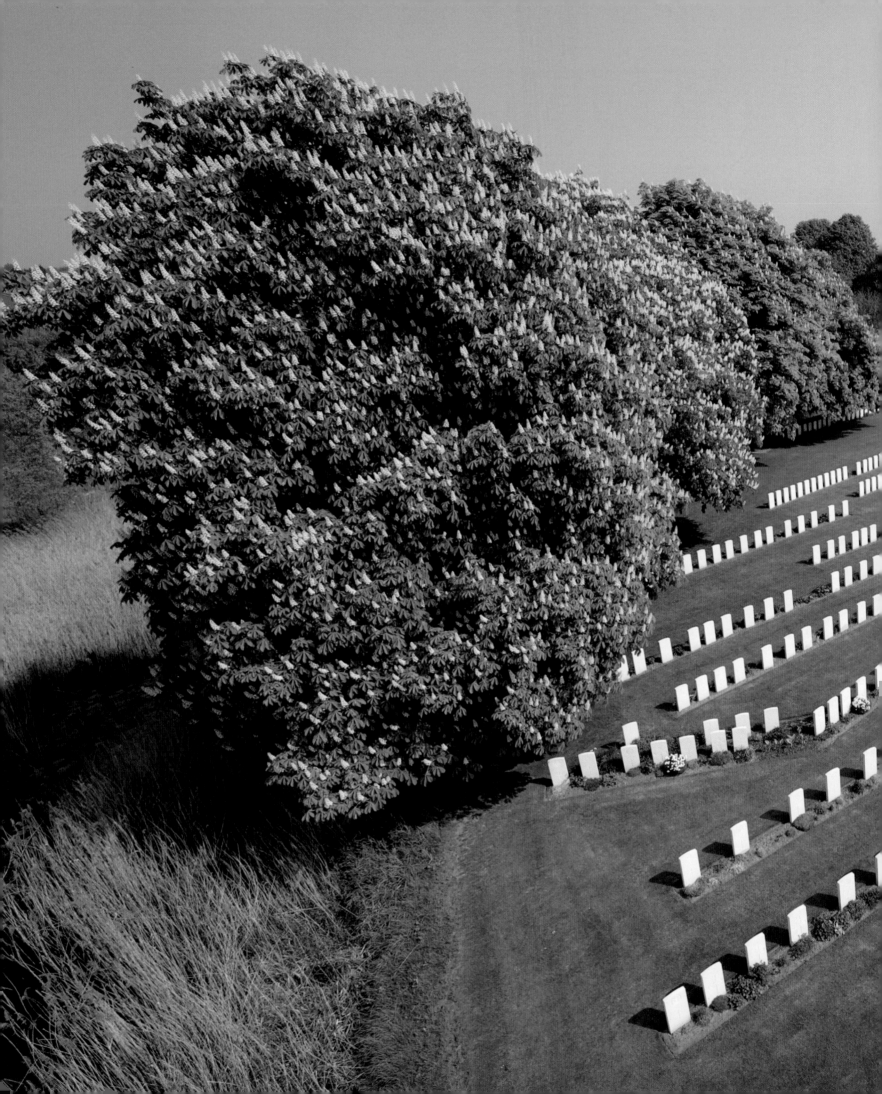

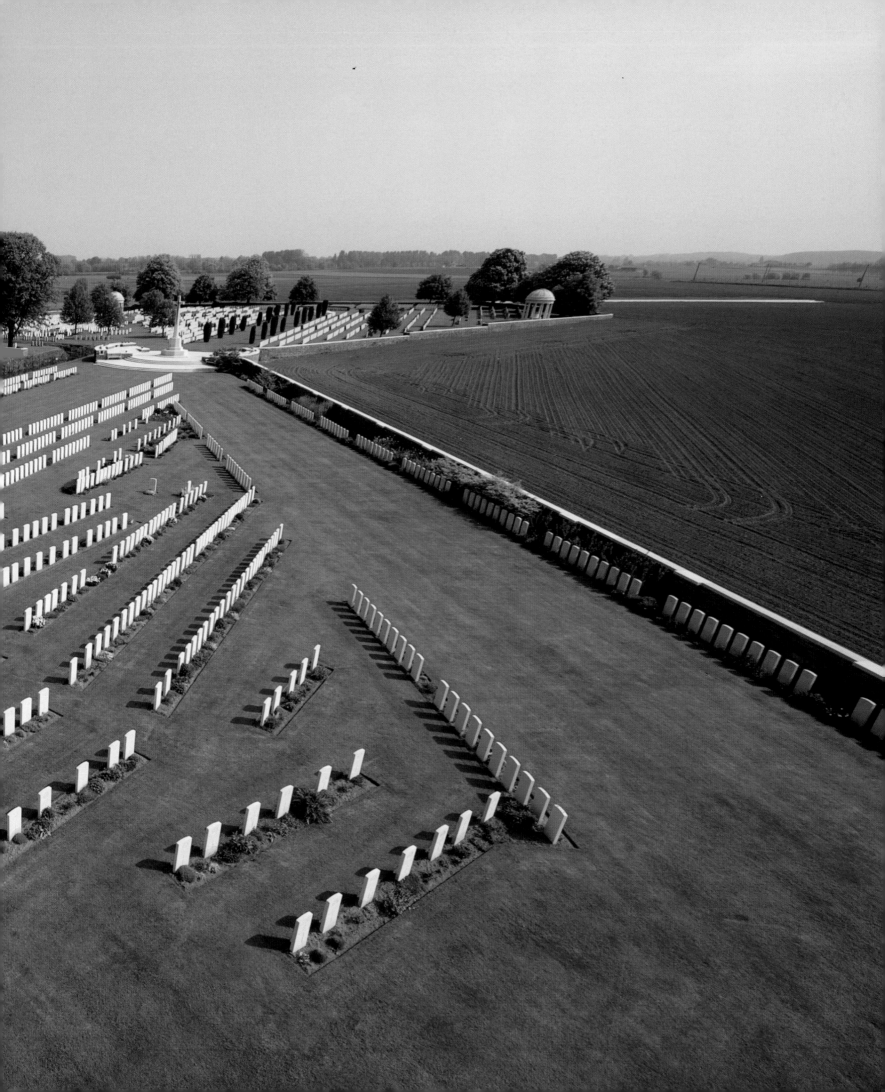

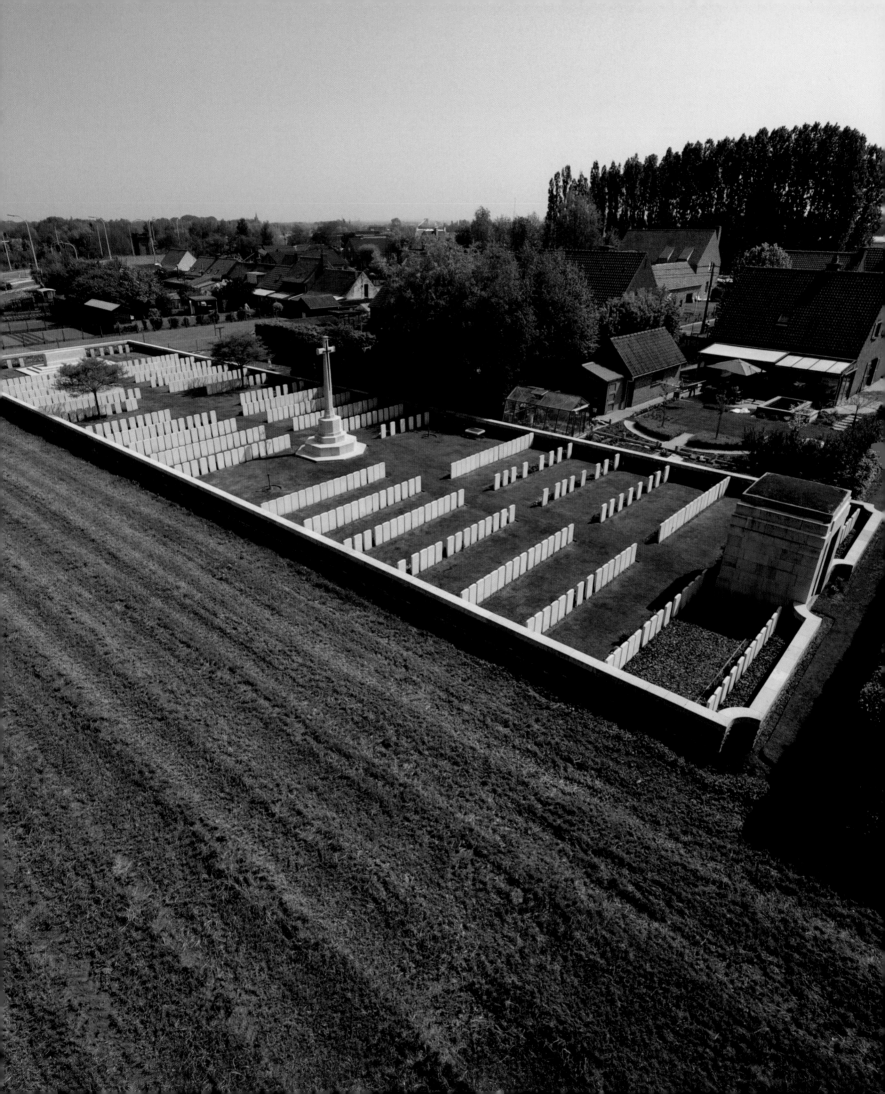

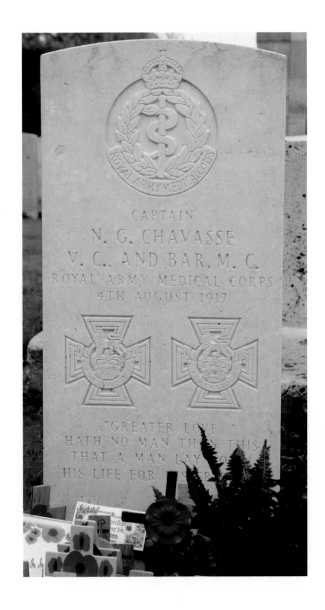

The grave of Captain NG Chavasse VC and Bar, MC, in Brandhoek New Military Cemetery,
a British medical doctor and one of only three people to be awarded the Victoria Cross twice.

PAGE 48: Brandhoek New Military Cemetery.

PAGES 50–51: Pill Box, Hill 60.

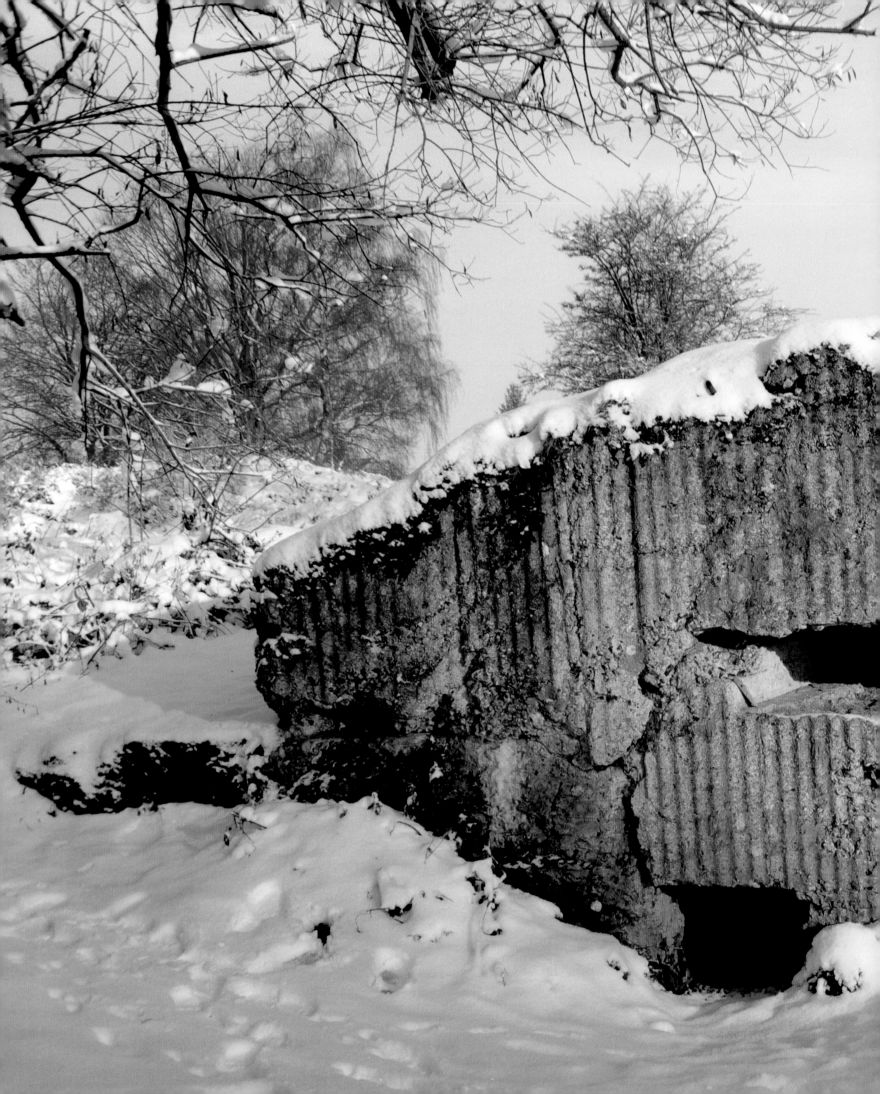

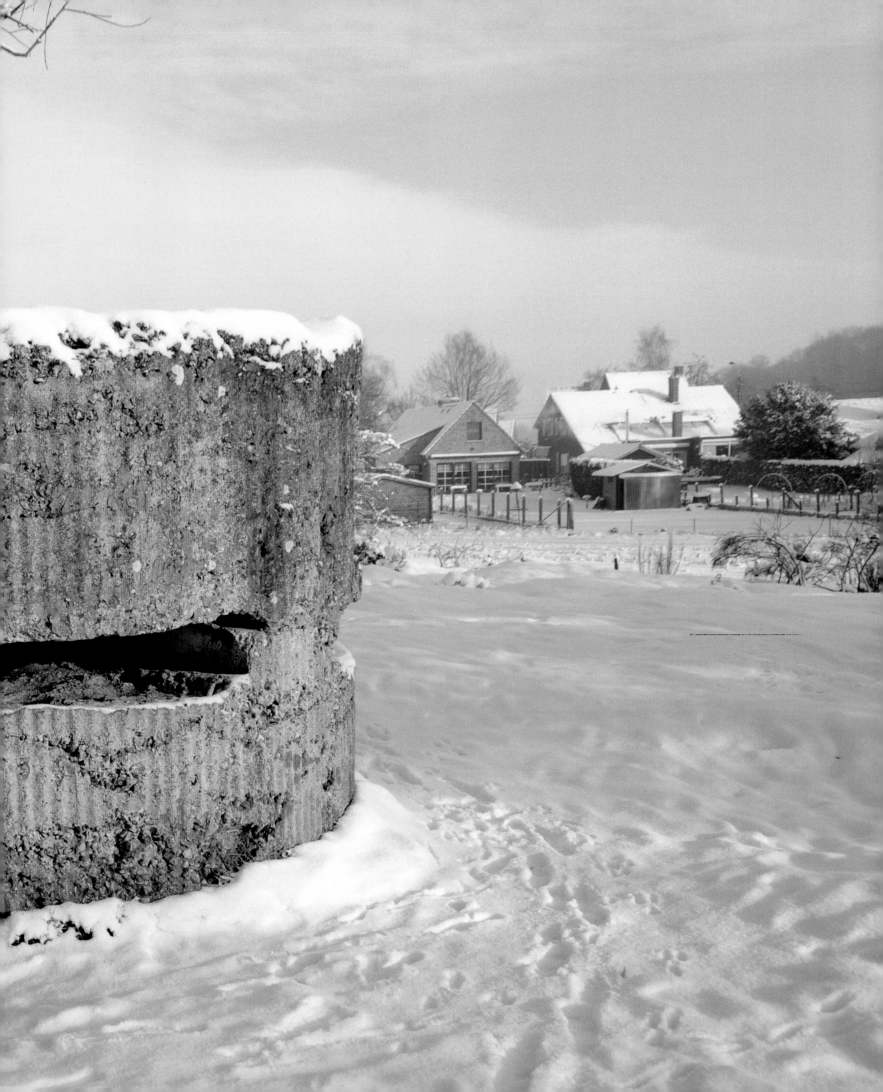

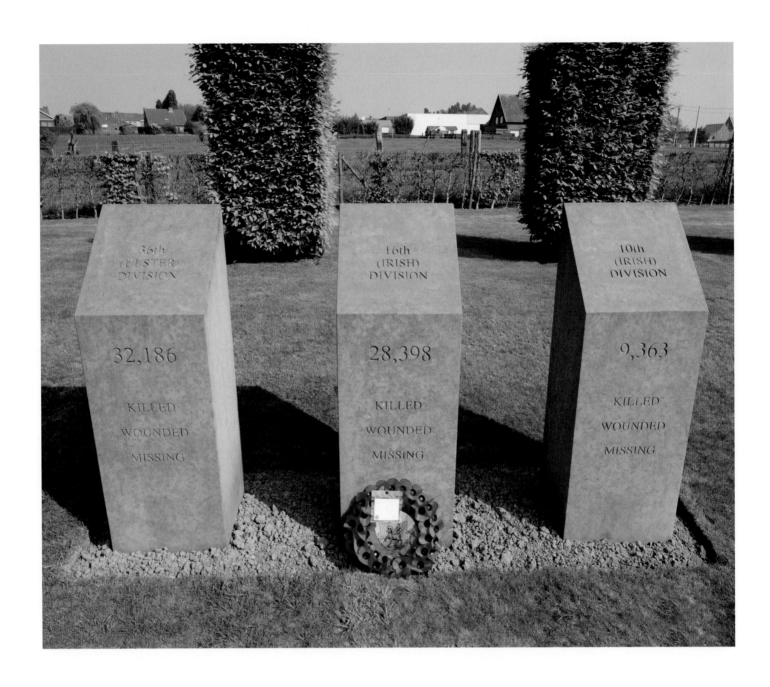

Island of Ireland Peace Park is a memorial to the soldiers of Ireland.
The 34-metre-high tower memorial, based on the traditional design of an
Irish round tower, is near to the site of the 1917 battle for Messines Ridge.

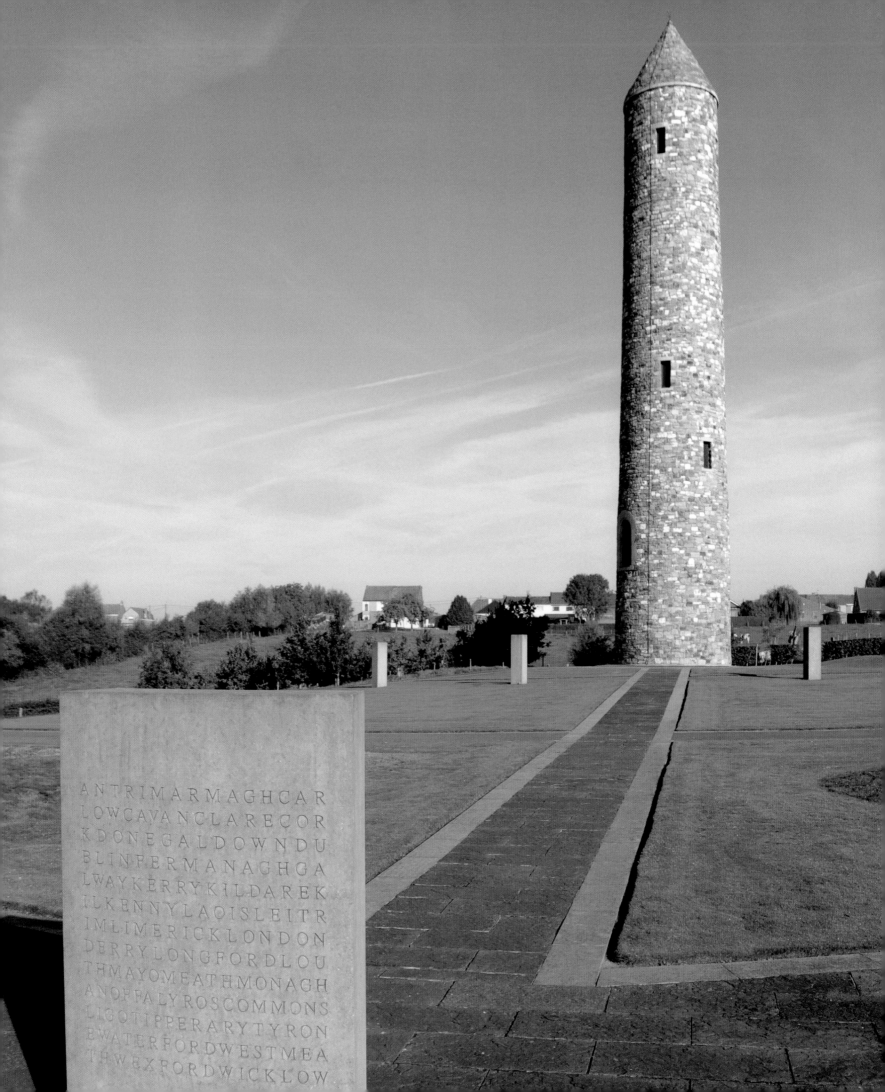

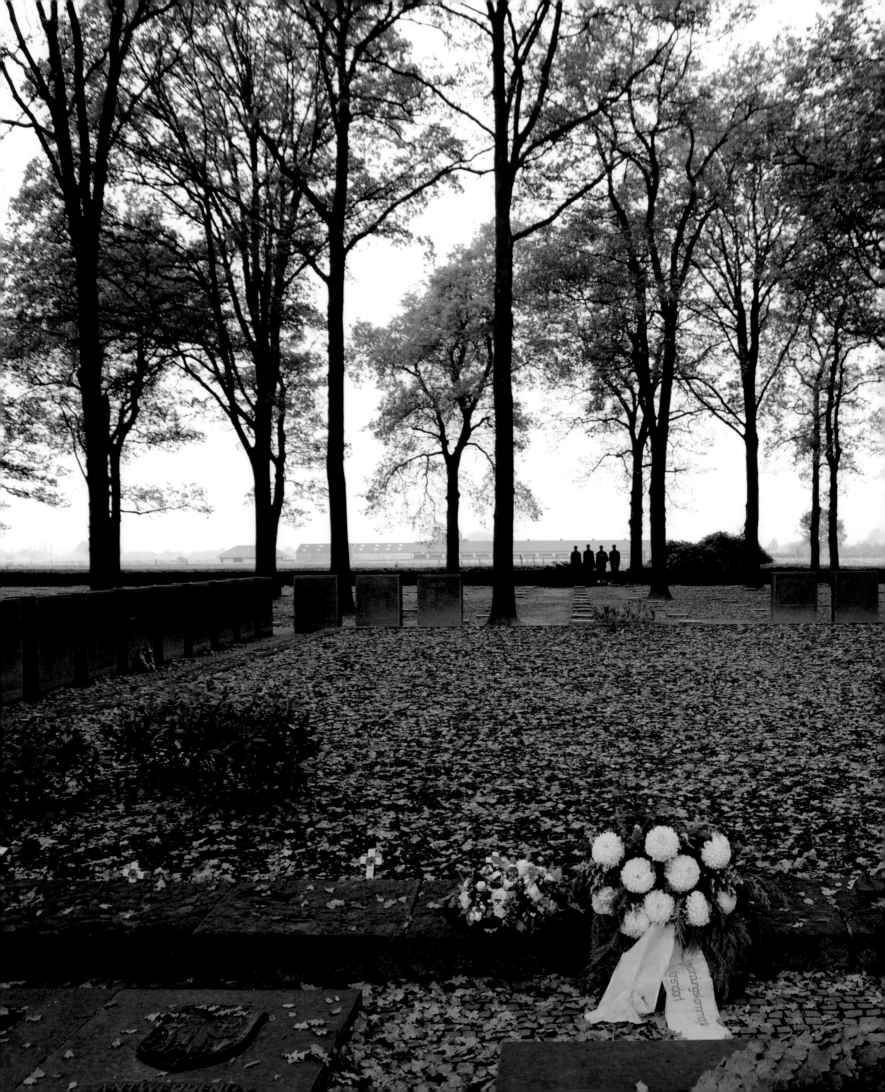

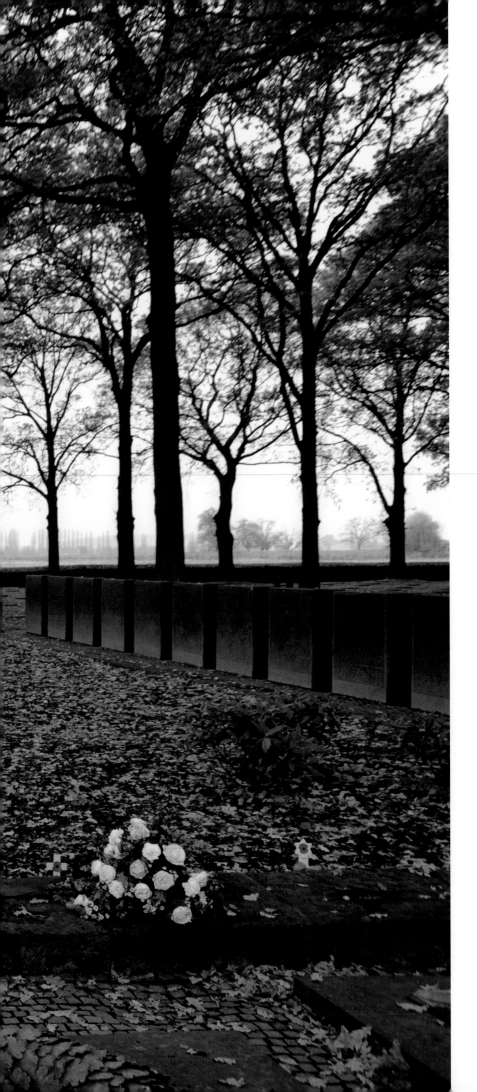

LANGEMARK
GERMAN CEMETERY

Langemark Cemetery is one of only four First World War German cemeteries in Flanders, inaugurated in July 1932. There are 44 294 war dead buried in this cemetery.

On the western boundary of the cemetery is a bronze statue of four mourning soldiers, watching over their dead comrades (pages 56–57), by sculptor Emil Krieger. The *Kameraden Grab* (Comrades Grave) contains the remains of 24 916 unidentified German soldiers.

Kameraden Grab (Comrades Grave)
for the unidentified dead.

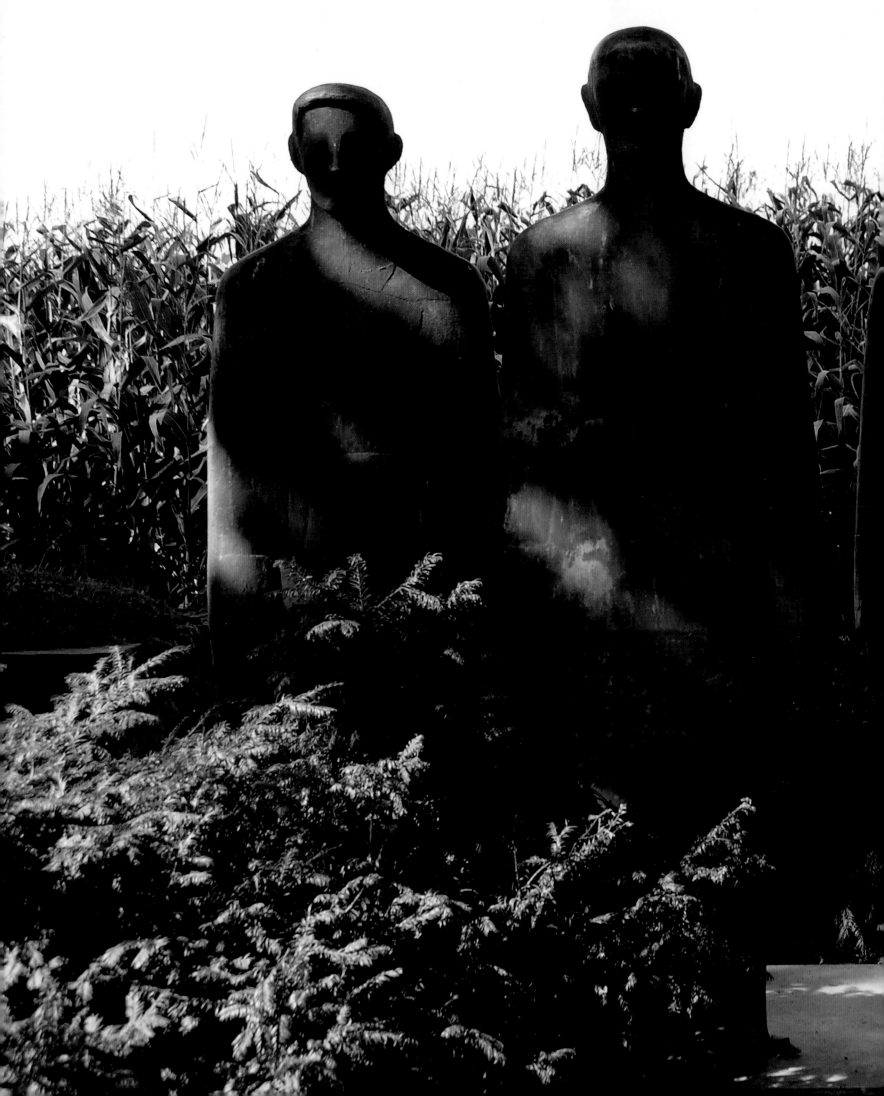

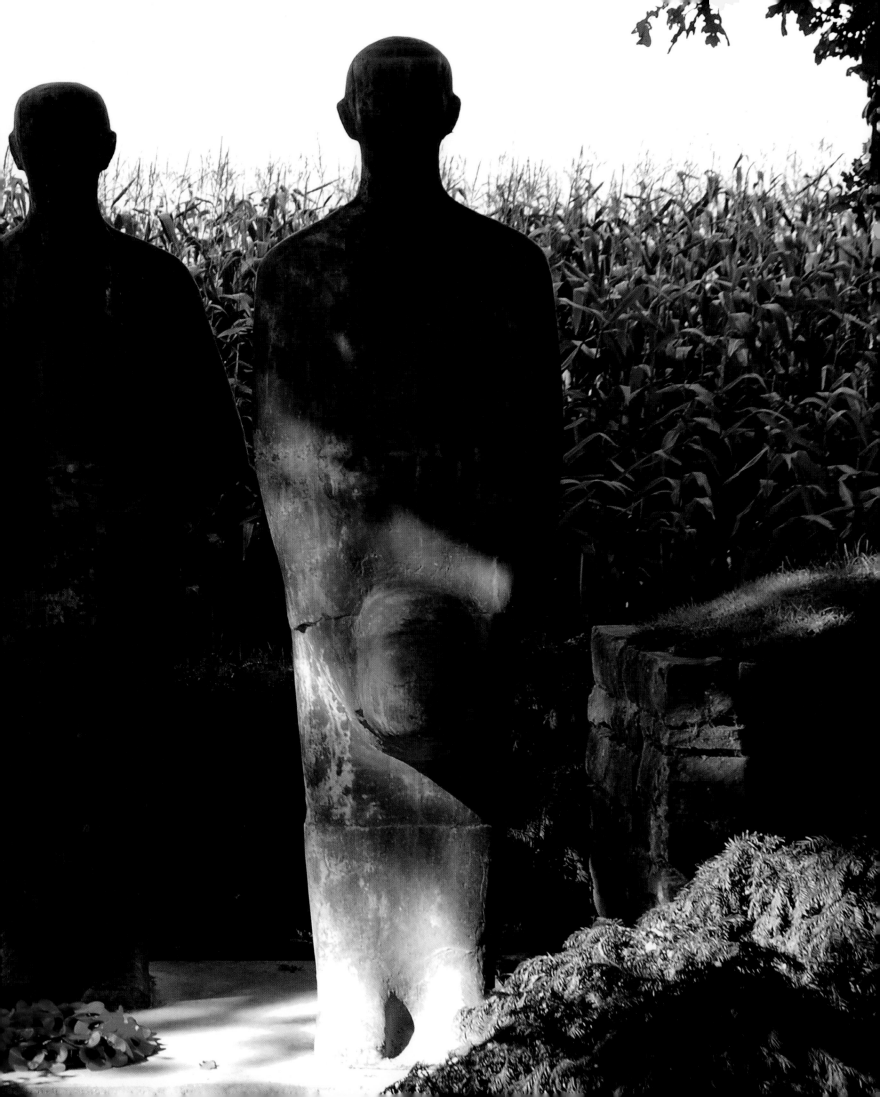

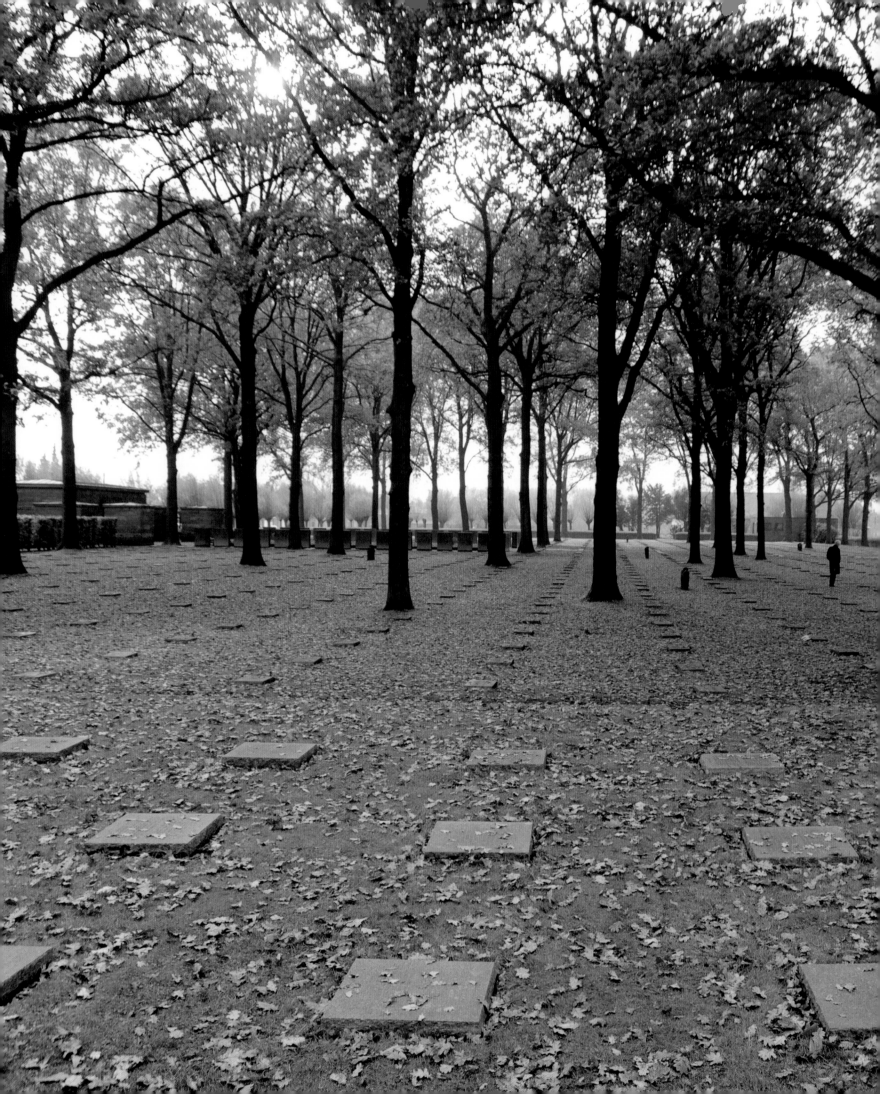

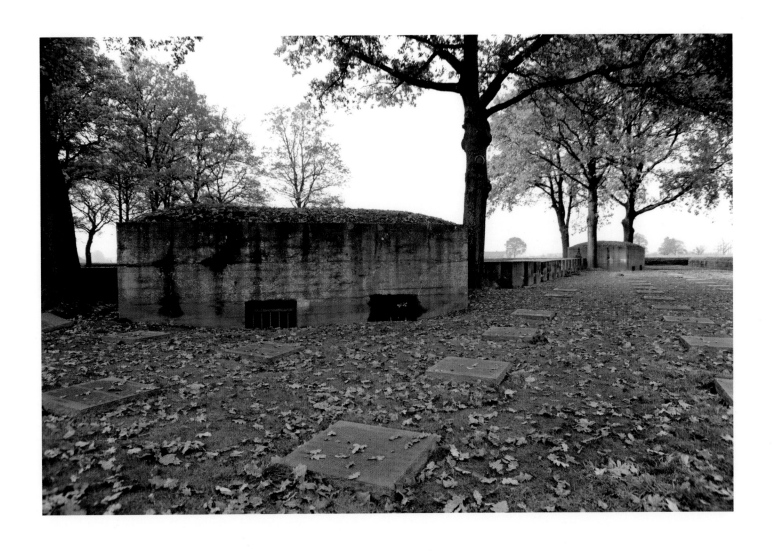

German bunkers form part of the cemetery architecture.

PAGE 58: Stone grave markers beneath oak trees – the national tree of Germany.

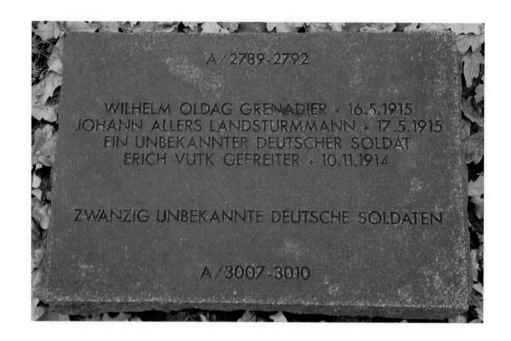

A/2789-2792

WILHELM OLDAG GRENADIER · 16.5.1915
JOHANN ALLERS LANDSTURMMANN · 17.5.1915
EIN UNBEKANNTER DEUTSCHER SOLDAT
ERICH VUTK GEFREITER · 10.11.1914

ZWANZIG UNBEKANNTE DEUTSCHE SOLDATEN

A/3007-3010

Stone grave marker.

PAGE 61: A basalt-lava cross stands on one of three German bunkers that
have been incorporated into the cemetery.

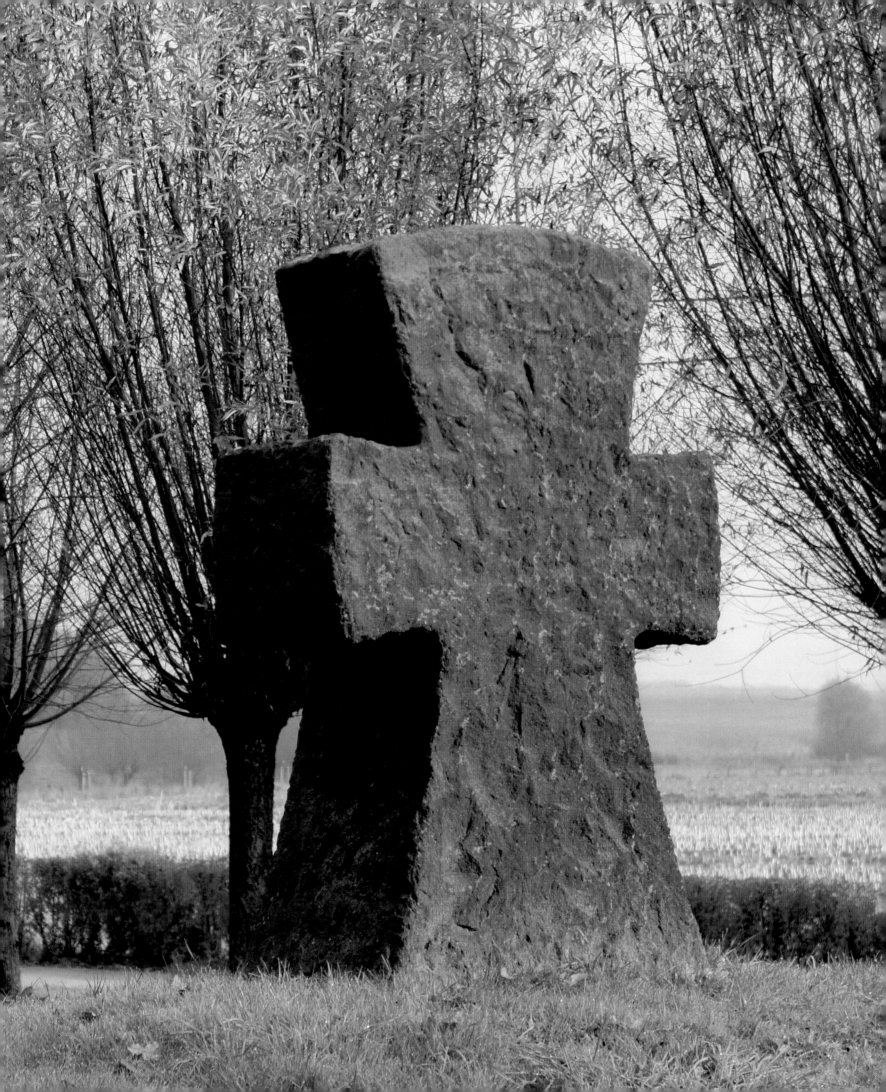

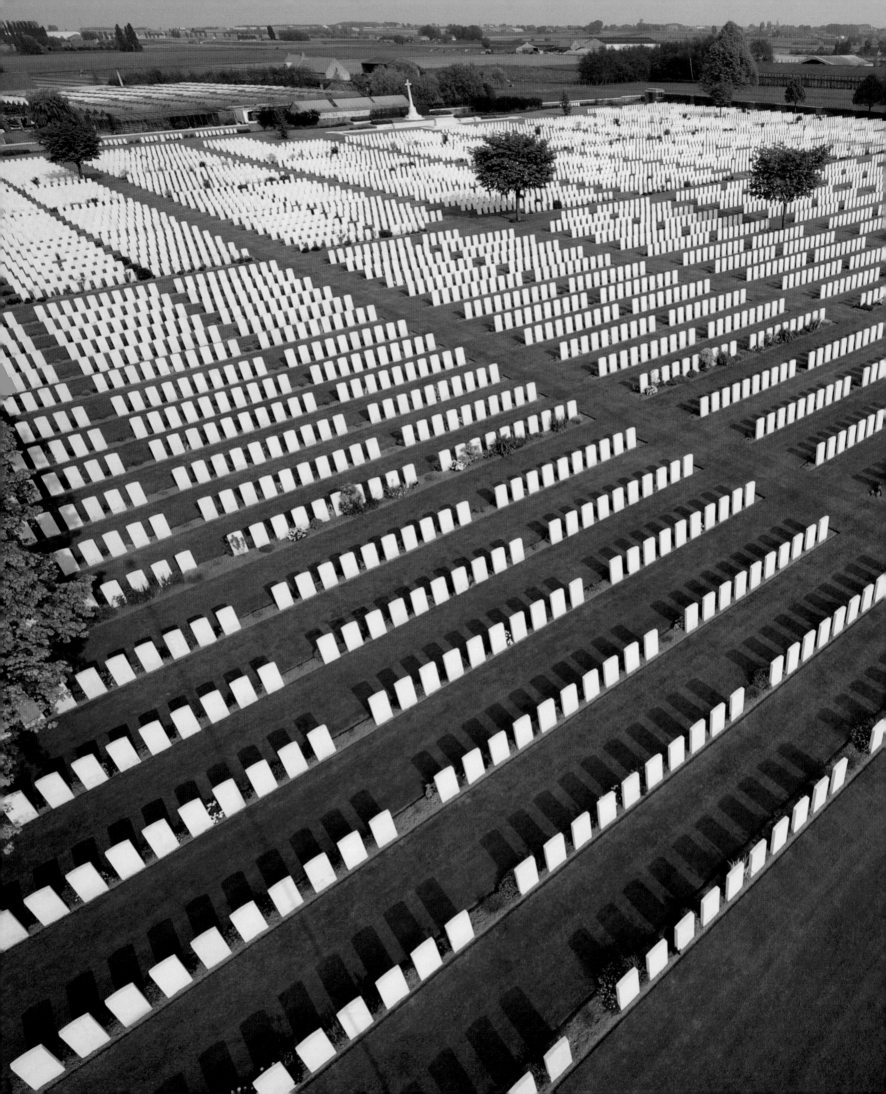

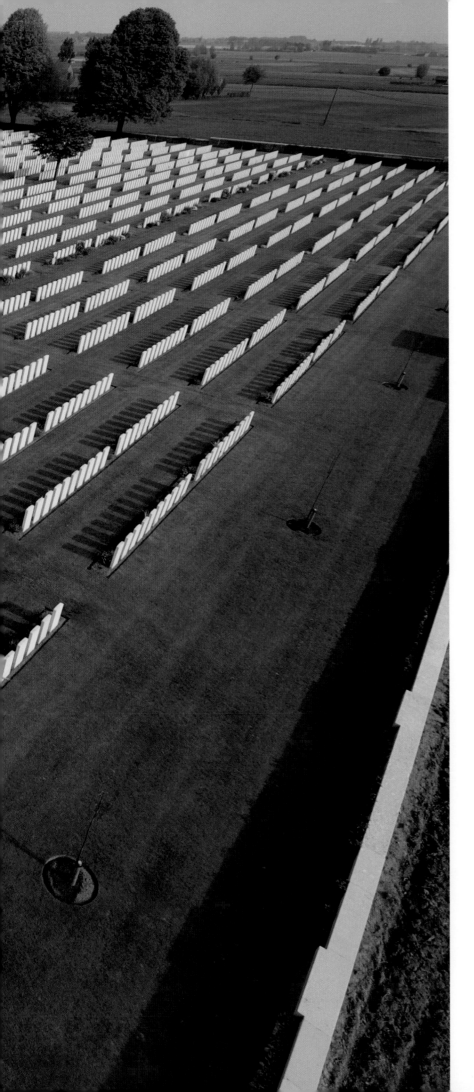

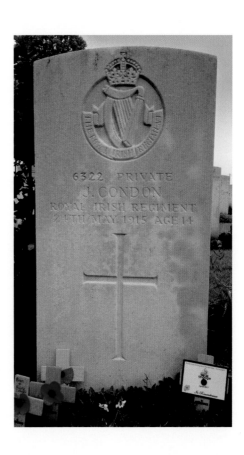

The grave of Private J Condon, thought
to be the youngest battle casualty of the war.

pages 62–63: Poelcapelle British Cemetery.

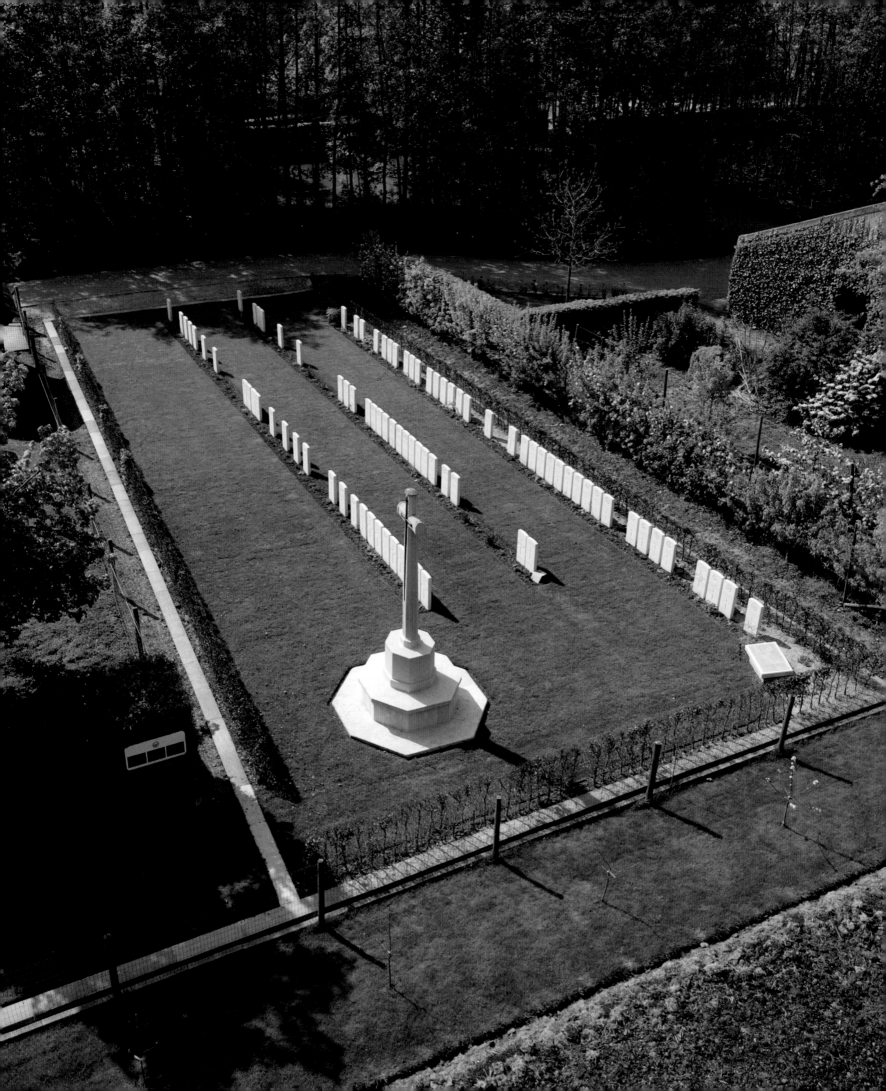

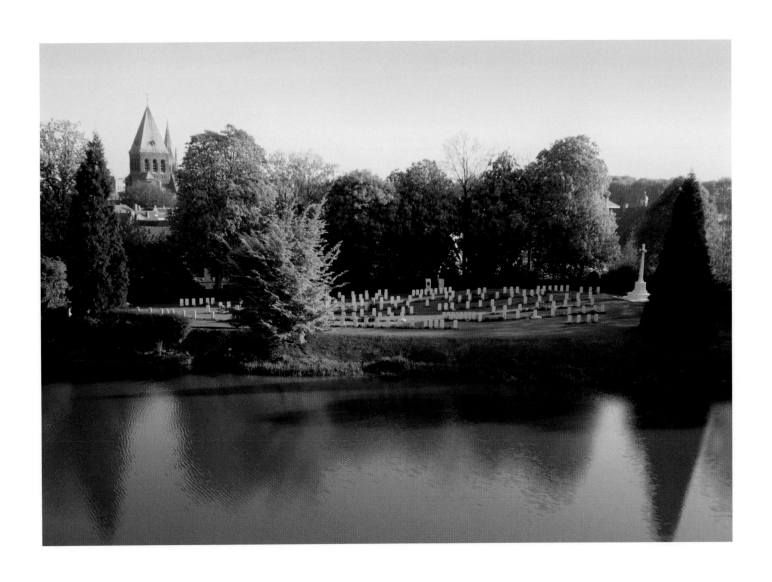

Ramparts Cemetery, Lille Gate.
PAGE 64: Railway Chateau Cemetery.

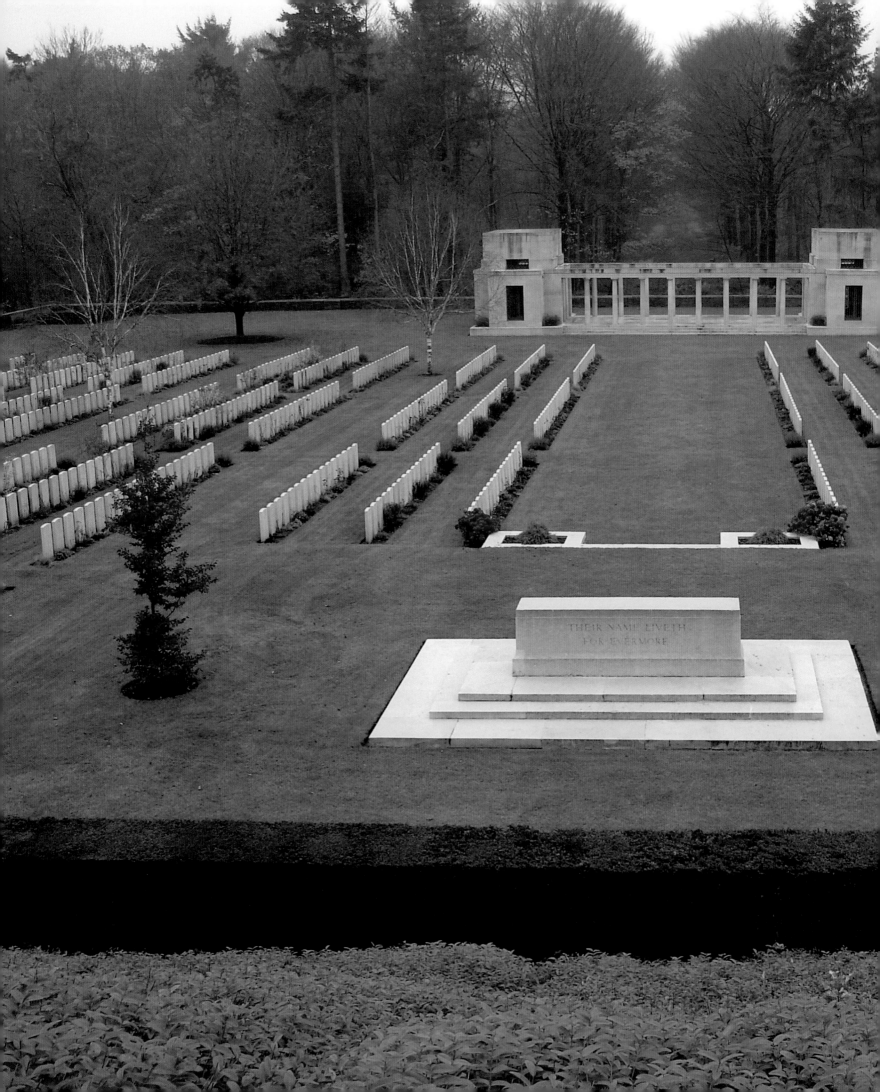

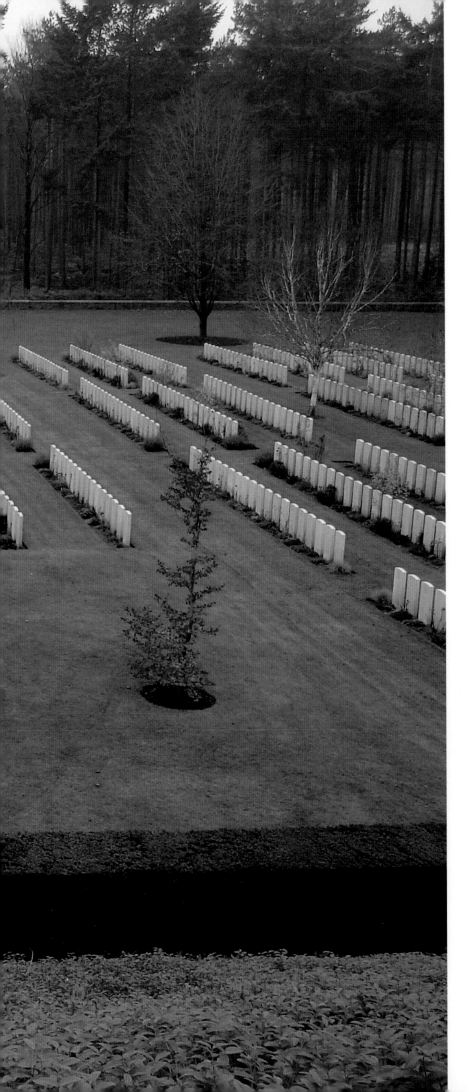

BUTTES NEW BRITISH CEMETERY

Located near Zonnebeke and Polygon Wood this cemetery is the final resting place or memorial to 2 108 Commonwealth servicemen.

On top of the Butte stands the Battle Memorial to the 5th Australian Division who captured it in September 1917. On the opposite side of the cemetery is the Buttes New British Cemetery (New Zealand) Memorial, which commemorates the 378 officers and men from the New Zealand Division who died in the Polygon Wood sector between September 1917 and May 1918 'and whose graves are known only to God'.

A walled avenue connects this cemetery to the Polygon Wood Cemetery, a much smaller front-line cemetery.

The inscription that is carved on the Stones of Remembrance in every large Commonwealth war cemetery,

Their Name Liveth For Evermore

was selected by Rudyard Kipling and is taken from *Ecclesiasticus* 44:14. He was also responsible for the phrase 'Known Unto God' inscribed on the gravestones of the unknown.

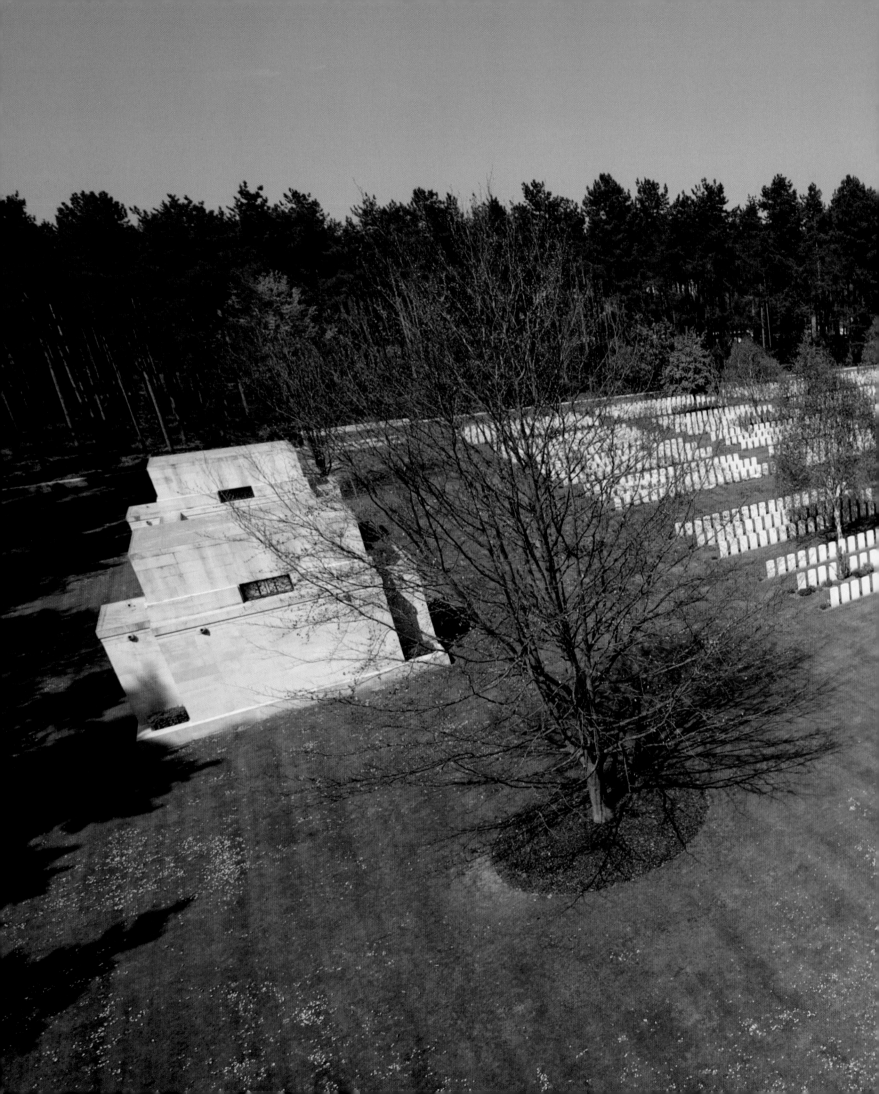

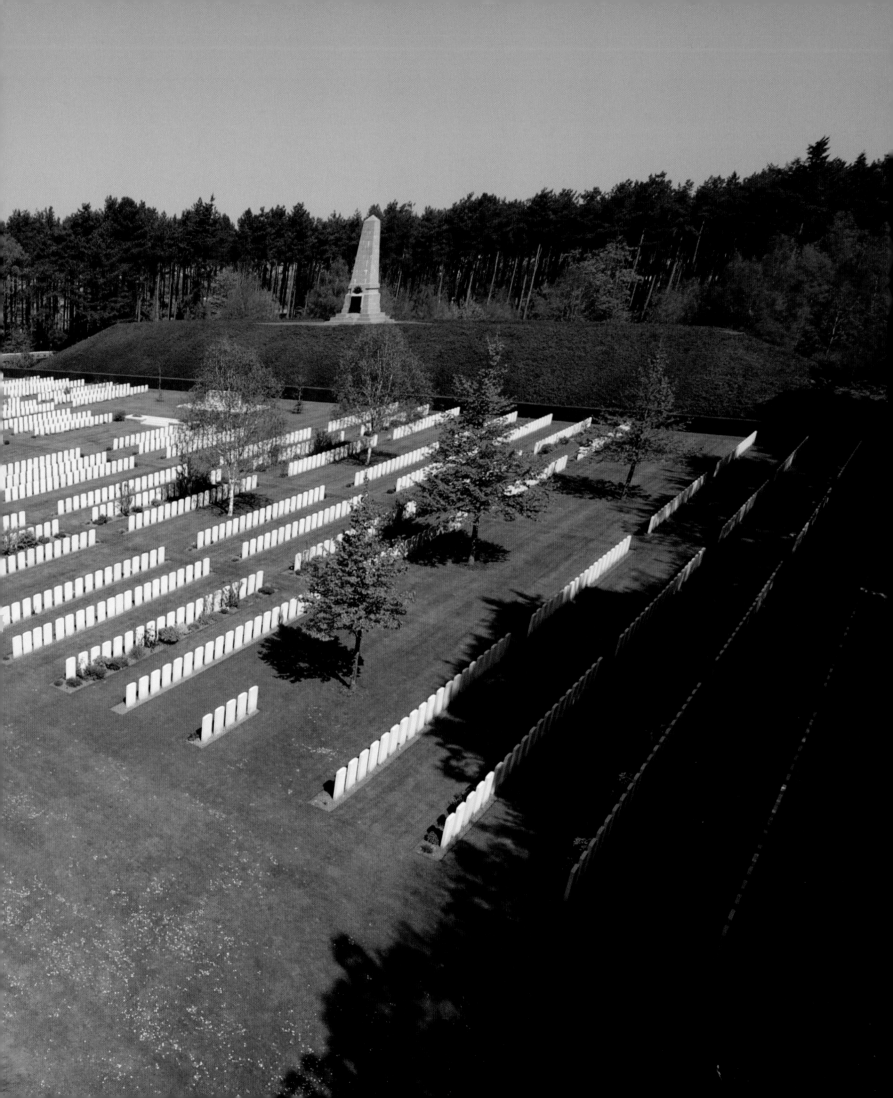

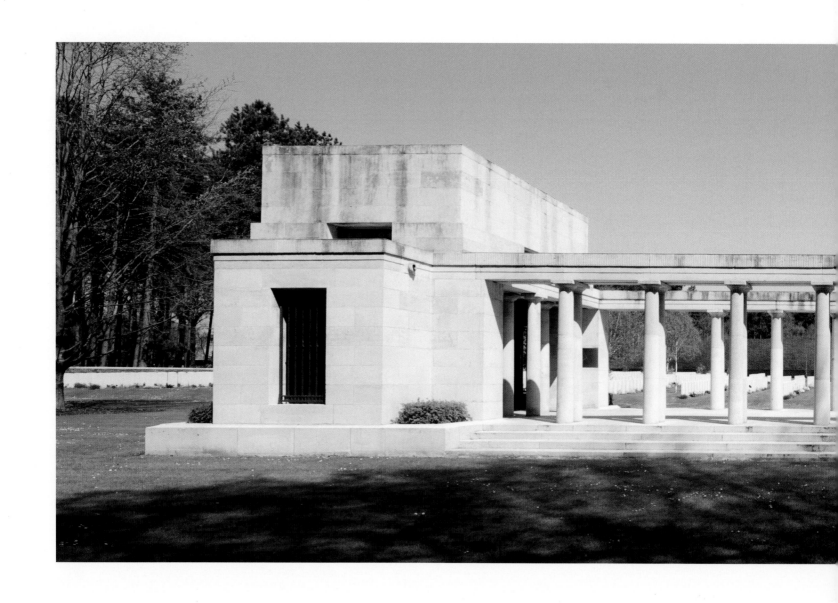

Buttes New British Cemetery (New Zealand) Memorial.

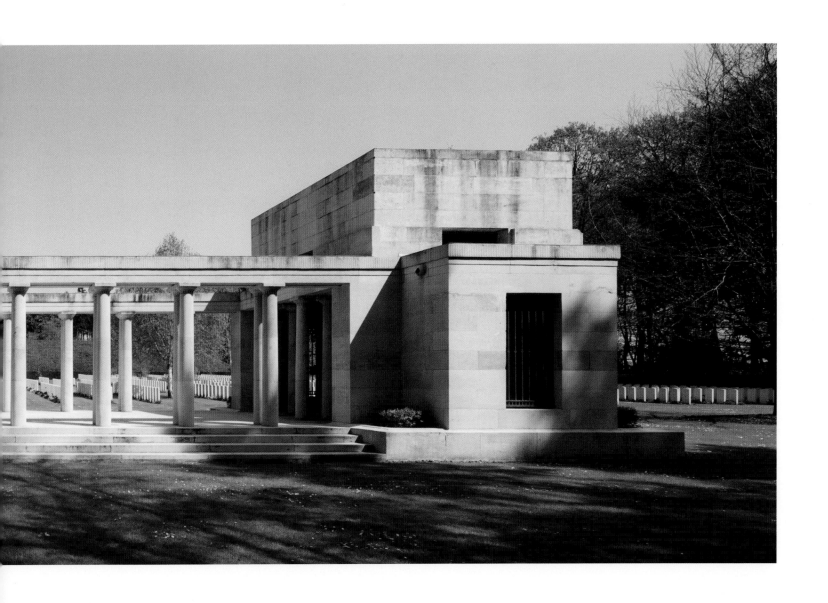

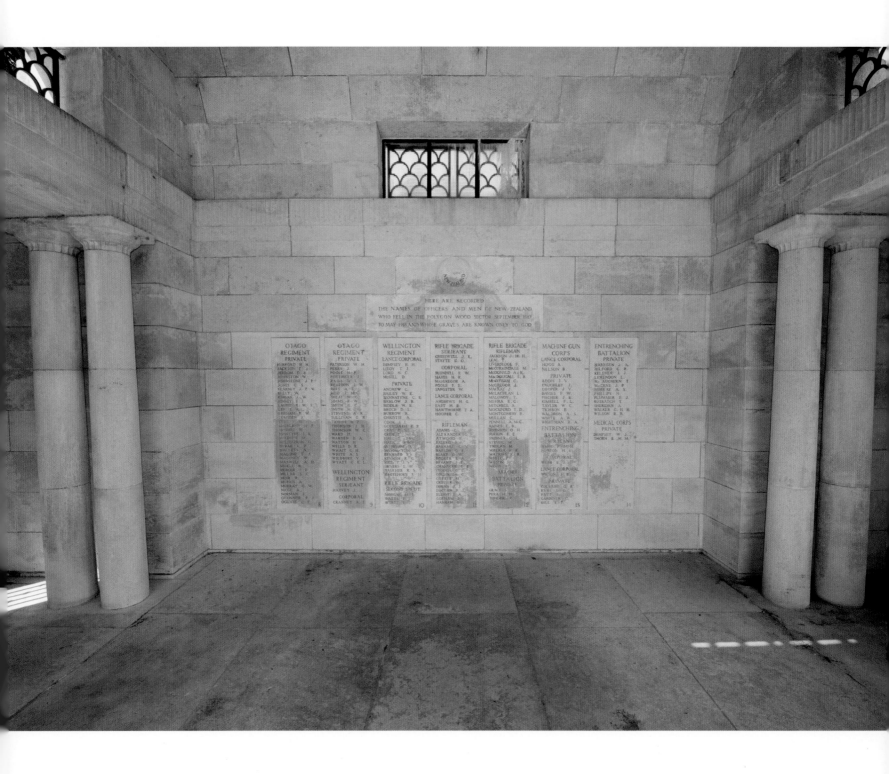

Buttes New British Cemetery (New Zealand) Memorial.
PAGE 73: On top of the Butte is the Battle Memorial of the 5th Australian Division.

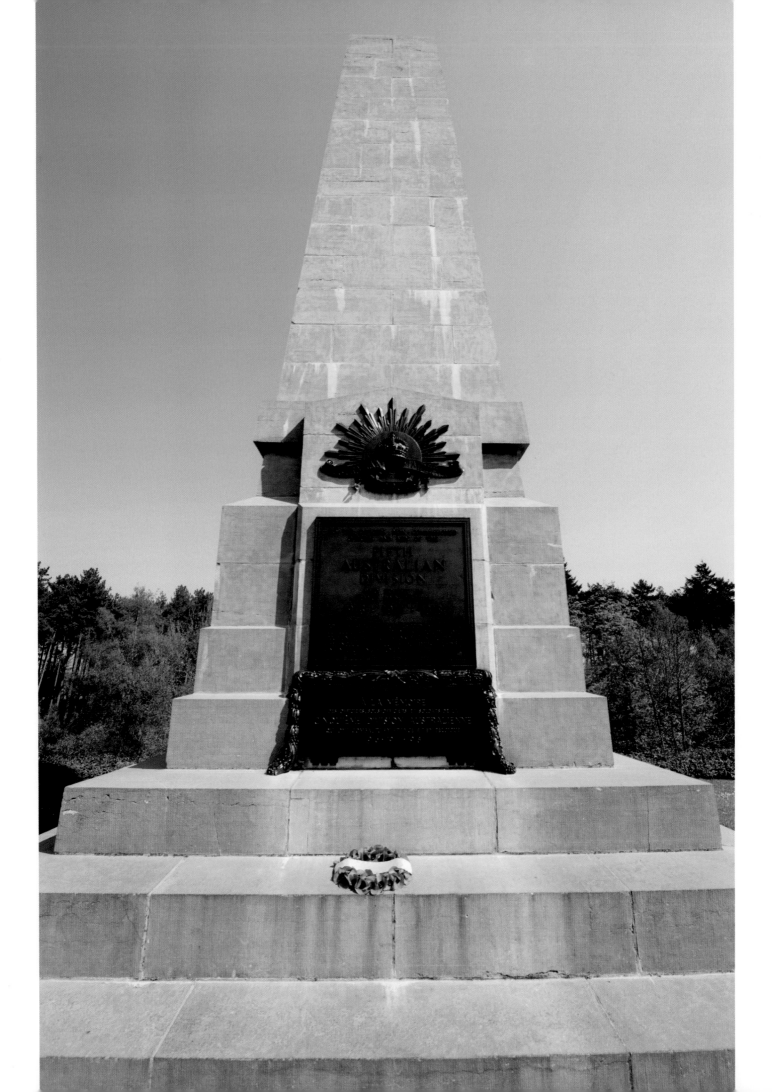

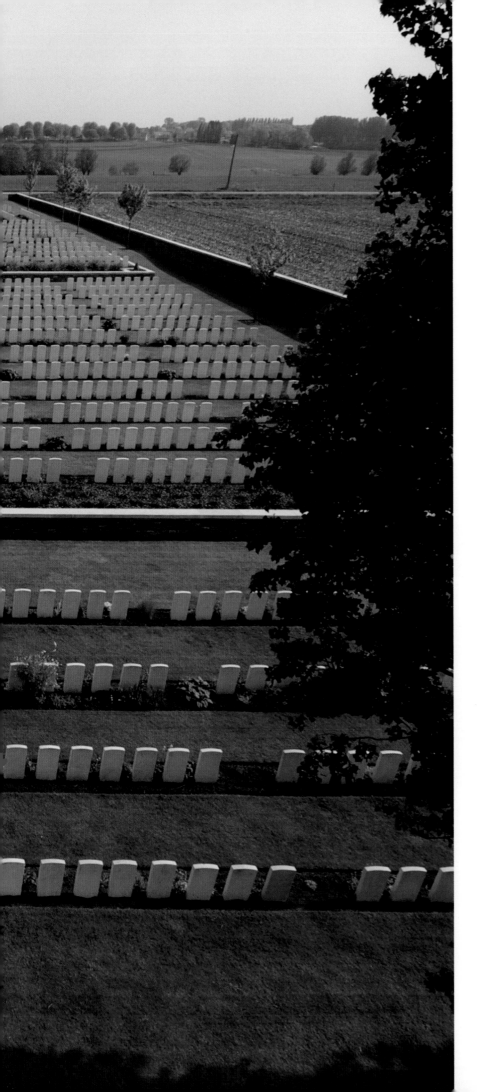

PASSCHENDAELE
NEW BRITISH
CEMETERY

This concentration cemetery created after the war contains 2101 graves, 1600 of which are unidentified. The bodies were collected from the battlefields of Passchendaele and Langemark after 1917.

The Graves Concentration Units searched the battlefields after the war. Any bodies found were identified where possible before being removed for burial in one of the concentration cemeteries such as this one, Bedford House Cemetery and Tyne Cot Cemetery.

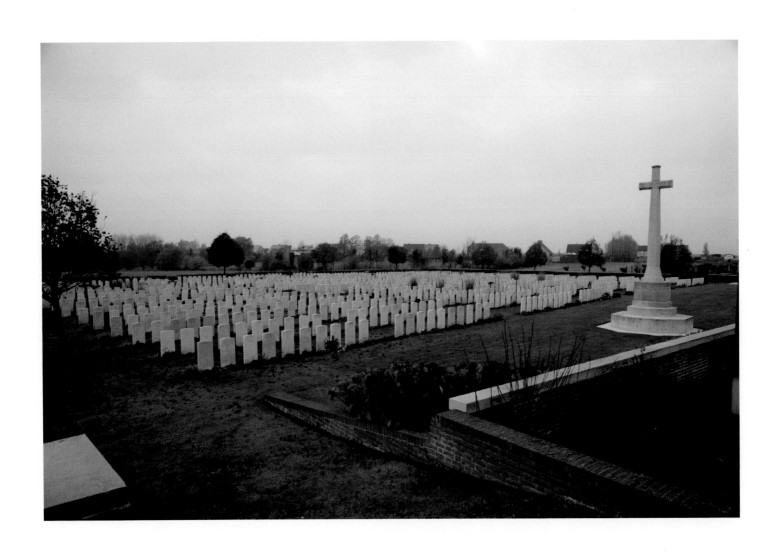

Artillery Wood Cemetery.

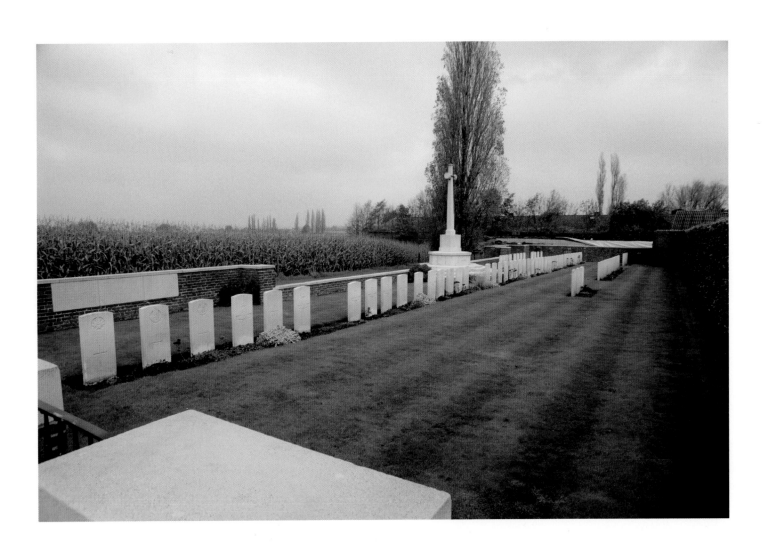

Rousseau Farm Cemetery.

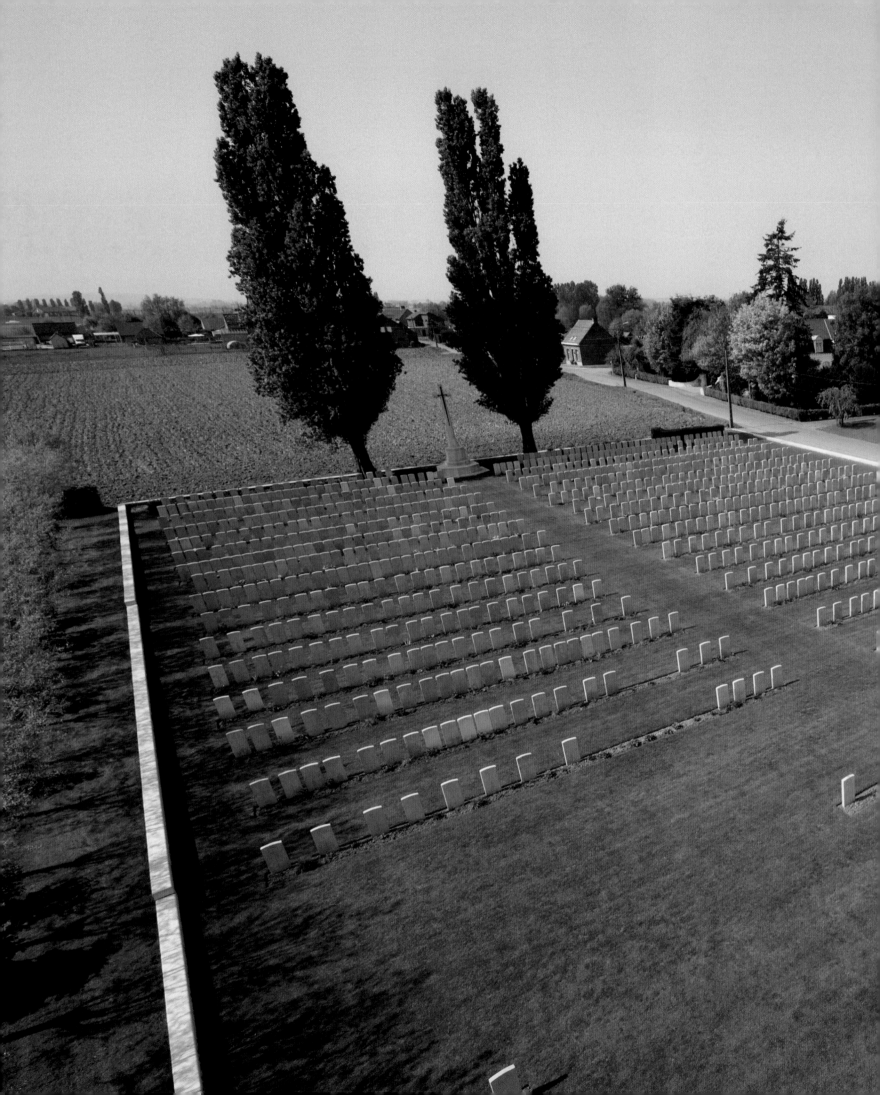

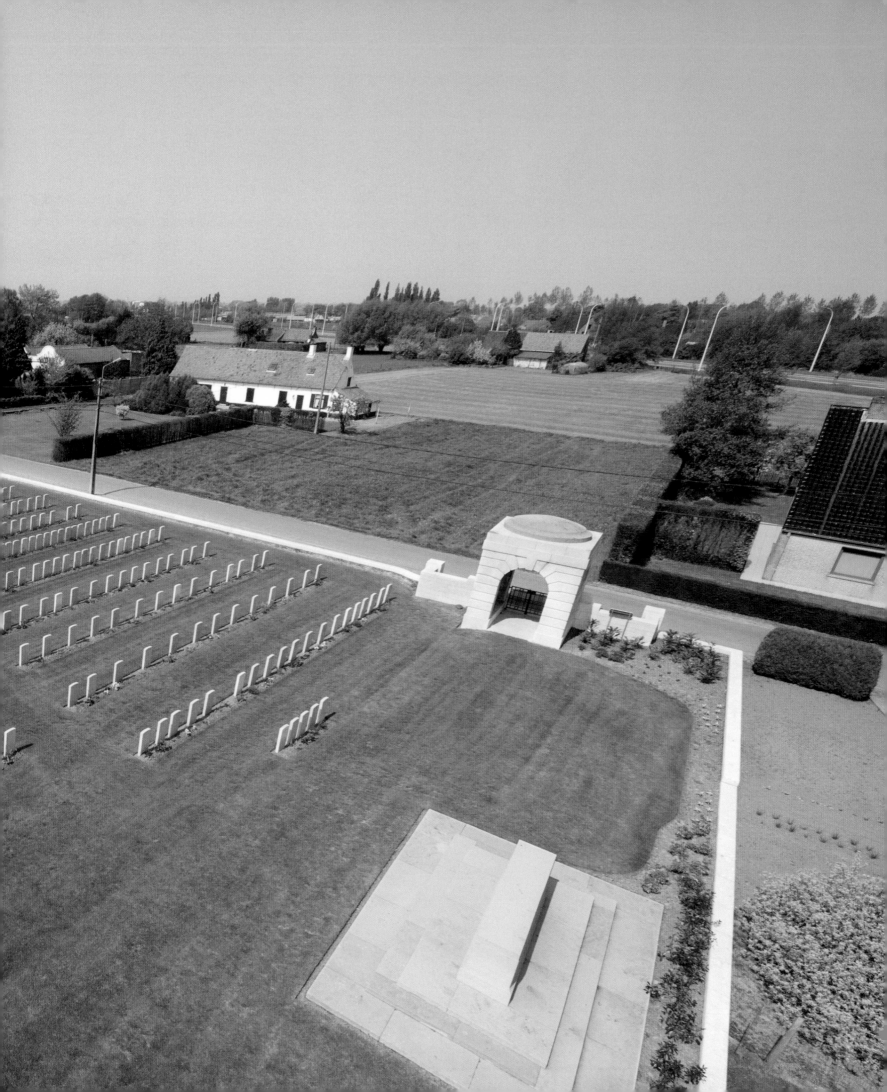

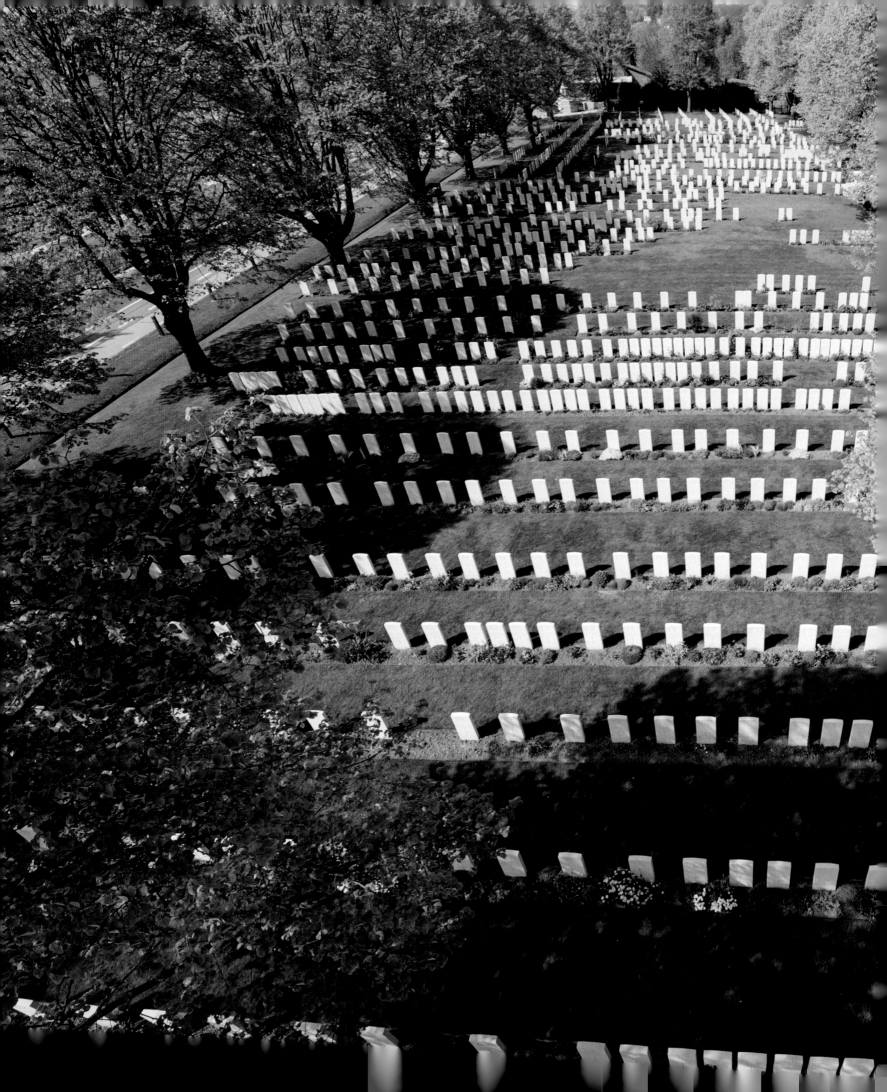

PAGES 78–79: Brandhoek New Military Cemetery No. 3.
PAGES 80–81: Essex Farm Cemetery.
PAGES 82–83: Hooge Crater Cemetery.

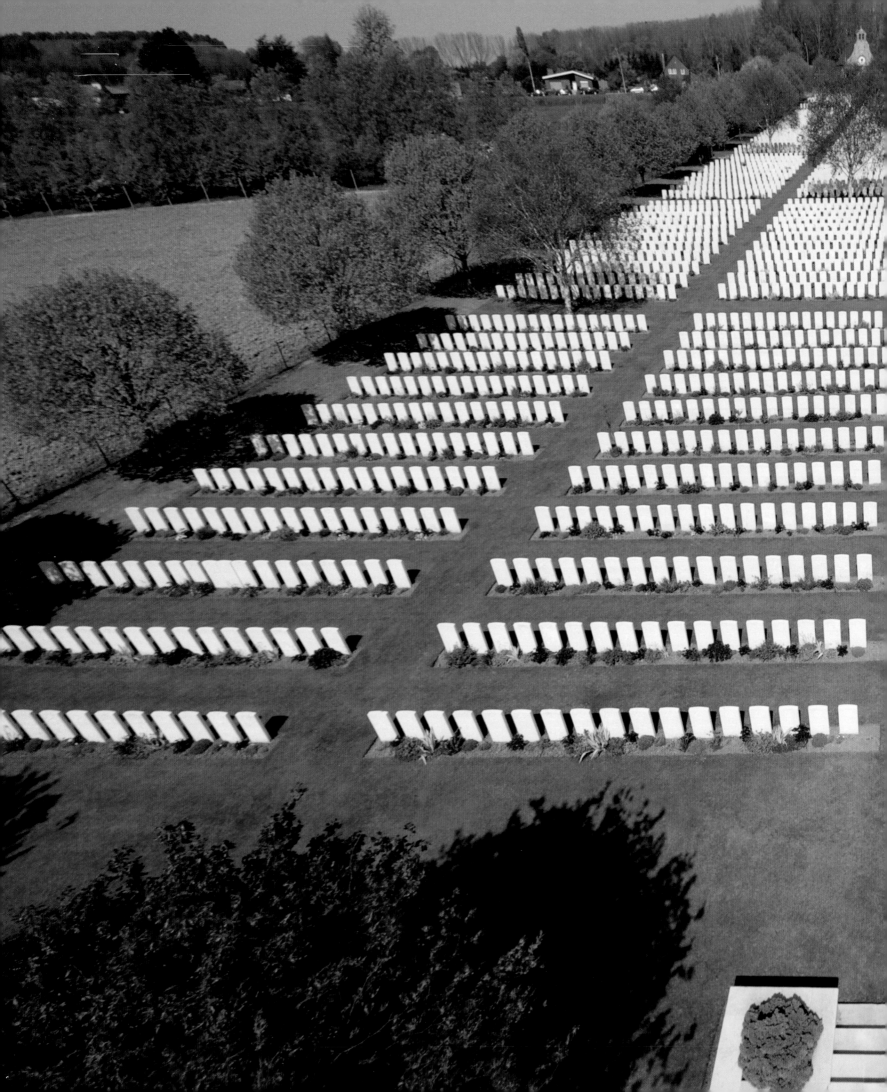